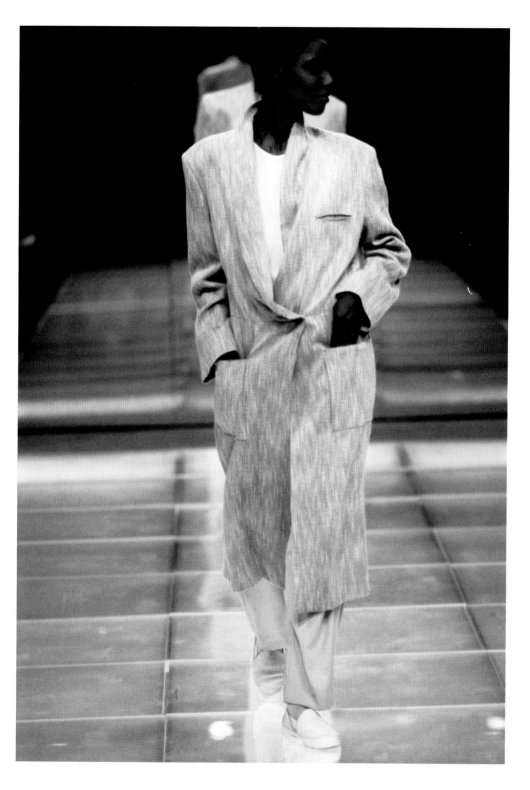

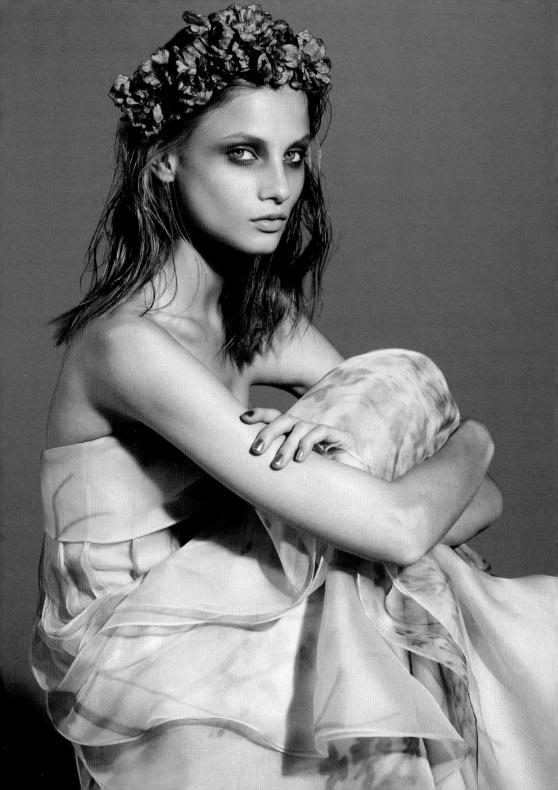

VOGUE ON

GIORGIO ARMANI

Kathy Phillips

quadrille

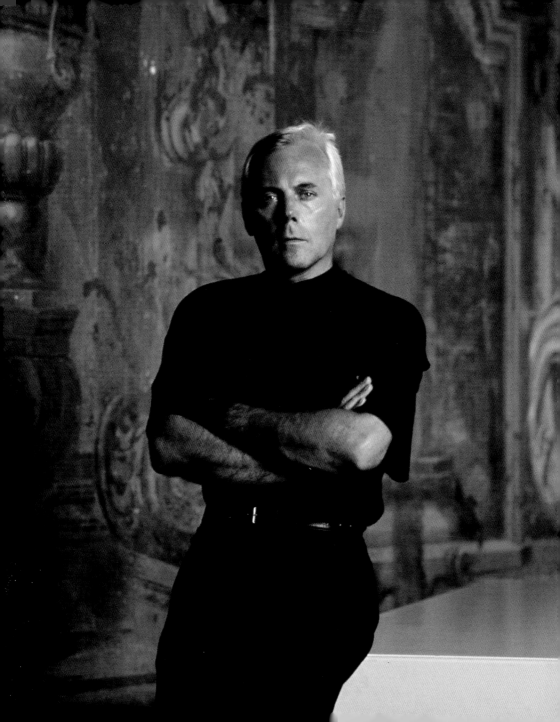

Re Giorgio – 'King Giorgio' – photographed in 1989 by Snowdon.

page 1 Armani's 1984 soft, slubbed long-length coat is oversized and slouchy but still gives an indication of the body beneath. Photograph by Michel Arnaud.

previous page A strapless, palest pink and grey-blue painterly, flower-sprigged tulle full-length dress with floating petal hem from the 2009 spring collection. Photograph by Terry Tsolis.

'I CREATED ALL MY WORK AROUND
THE JACKET. IT WAS MY POINT OF
DEPARTURE FOR EVERYTHING.'

GIORGIO ARMANI

THE DAY OF
THE JACKET

Posterity often remembers those who saw things differently, and Giorgio Armani saw the jacket in a way that no one had seen it before. He understood not just what fashion needed, but what it didn't, removing everything he deemed unnecessary, from buttons to cuffs, to arrive at a purer essence of style. Nothing typified this approach more than his iconic deconstructed jacket. By removing the rigid linings, inner linings and paddings Armani liberated the fabric from a fixed shape and allowed the wearer to dictate the form.

This liberation was a reflection of society too. Taking apart the highly tailored tradition in suits (that of Savile Row and military uniforms), easing the fit and therefore the image of the wearer coincided with fundamental changes of lifestyle, not just in Italy but globally. 'He was doing for the jacket what others were doing for philosophy, architecture and art,' wrote Dodie Kazanjian in American *Vogue*. 'A minimalist look free of signature buttons or self-congratulatory logos that fitted right in with the zeitgeist.'

From his very first collections in 1975, Armani changed what was expected from the professional wardrobe. 'The fashion press were dumbstruck by what they saw,' wrote Natalia Aspesi, Italy's foremost fashion writer. 'Were these creations – simple light garments, below the knee hemlines, soft trousers, jackets like shirts without ornamentation – impudence or extravagance, beautiful or ugly?' The following year his womenswear, aptly, followed suit. With masculine-cut deconstructed blazers and tweed or linen suits offset with soft, pleated skirts, Armani invented a look that would come to define the professional woman for the next decade. *La bella figura* – the Armani way – offered new and subtle blends of fabrics, inventive weaves and colours, oversized versions of classic masculine shapes like the cardigan, the man's dress shirt and the trench coat. He also reversed the normal fashion order by designing for men before he became a womenswear designer, pioneering elegance and understatement and registering his dislike of what he called 'important' clothes.

'Giorgio Armani's secret weapon is focus,' says fashion writer Tim Blanks. Alasdair McLellan's 2011 photograph of Jourdan Dunn in an impeccably cut double-breasted wool jacket and trousers shows that to perfection. More than thirty years after his first reworking and reappraisal of the jacket, he is still in step with what women want to wear – and to keep.

overleaf In Armani's trouser suits, women looked feminine but were taken seriously. This double-breasted, pale blue crêpe jacket with matching waistcoat (not shown) and wide-leg trousers, worn by Carla Bruni, was photographed by Neil Kirk.

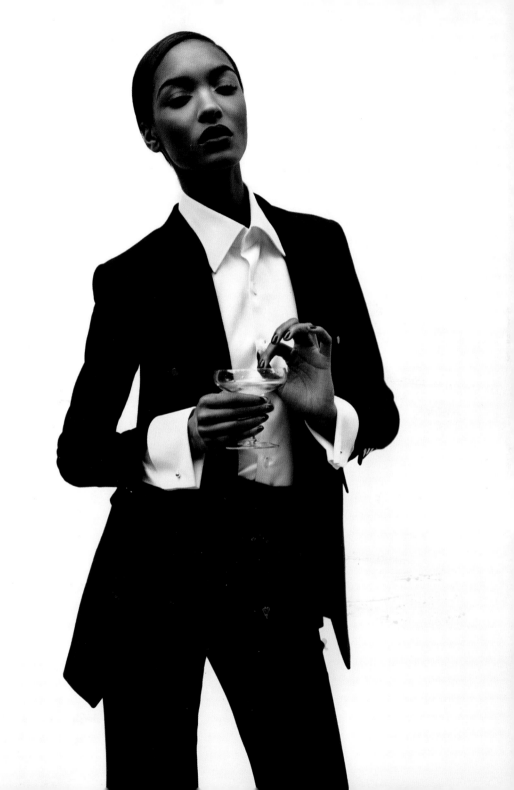

'THE NEW
WOMAN IN A
TROUSER SUIT
LOOKS LIKE
A WINNER.'

SARAH MOWER, VOGUE

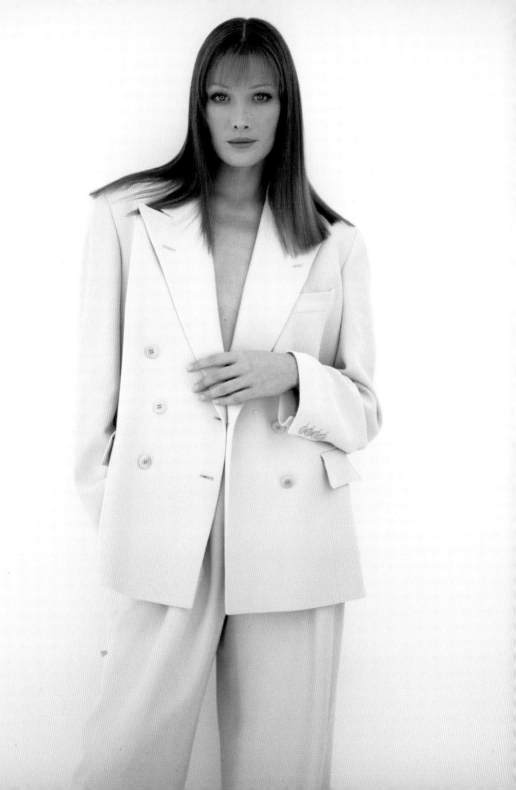

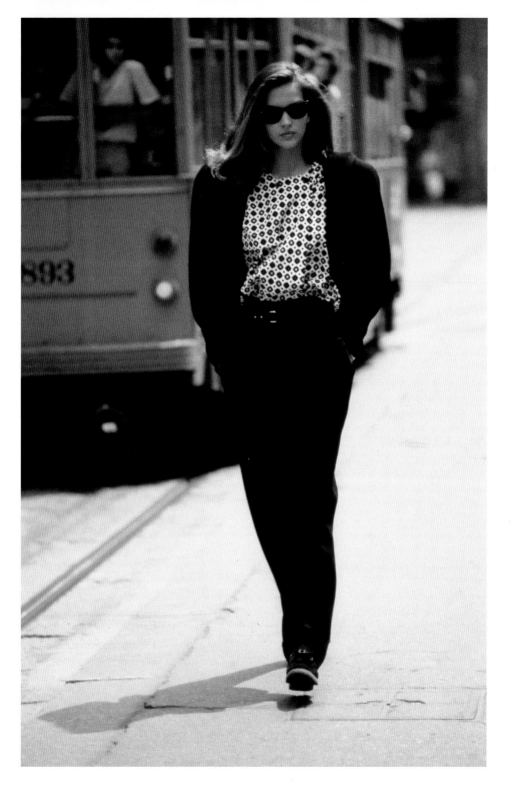

Small wonder then that his first inspirations also came from admiring men's wardrobes – the Duke of Windsor in his yellow cardigans, Gary Cooper in his simple t-shirts and even Picasso in his striped cotton matelot top.

'Armani will forever be known as the man who took his scissors to the structure of our clothes and yanked the claustrophobic skeleton out of them,' wrote *Vogue* describing the new quiet revolution in seventies fashion. 'The real star of the fashion picture is the wearer … Clothes are roomy; you need to be in better shape to move inside them … The International Collections showed clothes so free and flexible – it's time to be yourself, to suit your looks.'

These didactic messages on editorial pages of *Vogue*, mid-decade, could easily have been taken directly from Giorgio Armani's personal fashion manifesto. His revolutionary redesign of the silhouette was all about eliminating the unnecessary and at the same time enhancing the body. 'I wanted to take care of the human body,' he told Aspesi. 'This incredible machine that to this day remains a mystery. Mass-produced fashions made me feel old, shapeless, without glamour and I wondered why they had to be so heavy, awkward, like prisons that completely hid the body. At that time fabric and lining were joined together with glue that made the form rigid. I began to take everything away – padding, interfacing, linings, to look for fabrics that were classic in appearance but light like those used in women's fashions. To emphasise the shoulders in jackets but then let the rest undulate, adapt to the body, free from all constraints.'

'To understand Armani's achievement,' says eminent fashion writer Suzy Menkes, 'you have to see him as a link in a chain that goes back to the introduction of "tailor made" outfits in the Belle Epoque and continues through Gabrielle Chanel in the 1920s–30s and Yves Saint Laurent in the 1960s–70s.

'Real Life clothes' is how Vogue described a feature on 'Made in Italy' star choices in 1986. In Milan, Neil Kirk photographed Armani's new 'soft' tailoring in the form of a hooded black crêpe jacket, high-waisted, belted trousers and a black and white print crêpe de Chine collarless shirt from the Erreuno collection.

overleaf The man's wardrobe re-examined at Emporio Armani, then transposed into something soft and gentle in which the wearer can move easily and sensually. This palest blue softly tailored single-breasted jacket, camisole and palazzo pants (left) is androgynous and minimal. Photograph by Neil Kirk. Christy Turlington (right), photographed by David Bailey, wears the big-shouldered, wide-lapelled 'power suit' that typified fashion in the eighties. Designed in clotted cream wool crêpe, with horn buttons, and worn over a nun's veiling collarless shirt and chocolate suede belt, it is archetypical Armani.

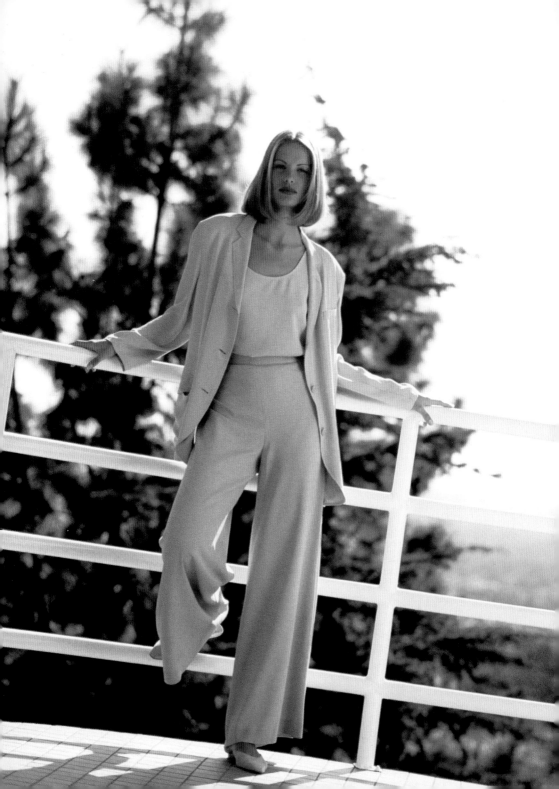

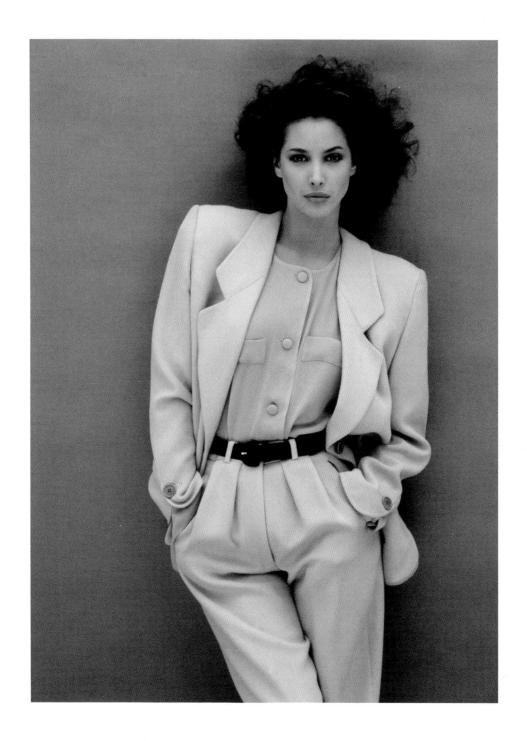

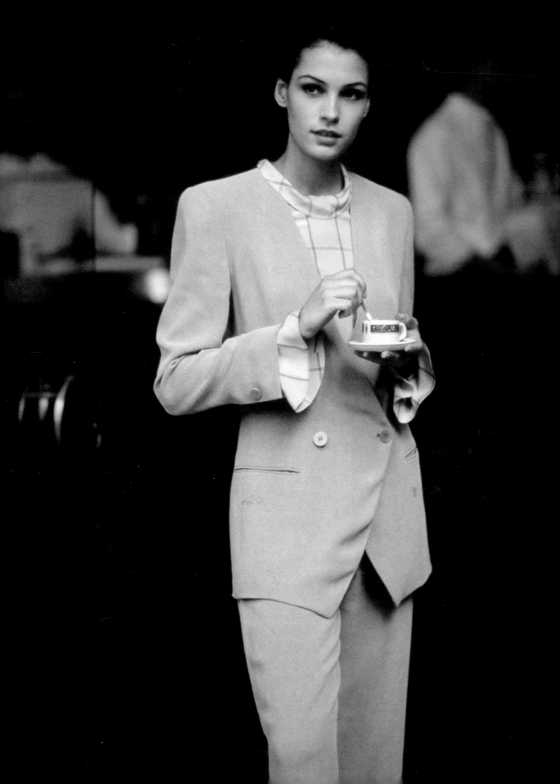

When Armani injected the ease of sportswear into tailored suits, it was not just a reflection of how a new generation felt about clothes, but also a reaction to their gym-honed bodies.'

Armani's new take on fashion was surfacing alongside political unrest and social change in Europe, and a time of violent demonstrations in Italy. 'In Italy, for 30 years under the Borgias, they had warfare, terror, murder and bloodshed, but they produced Michelangelo, Leonardo da Vinci and the Renaissance,' said Orson Welles's character famously in *The Third Man*. In the seventies, the political backdrop of strife coincided with a new approach to fashion that would become known as 'Il Made in Italy', and Giorgio Armani was at the forefront.

In 1968, Balenciaga, the great couturier, had closed his atelier in Paris explaining to *The Times*'s Fashion Editor, Prudence Glynn, that 'the life which supported couture is finished.' Queens, aristocrats and president's wives were no longer the ones who set fashions. By the beginning of the new decade it was actors and actresses, entertainers, rock stars and their wives who were photographed at nightclubs and publicity parties for their looks and style – fashion was no longer about social status. It was an unsettled time; and then came Armani who infamously ripped open the seams of the jacket, and a creased, deconstructed garment became elegant. 'There was a deliberately rumpled quality to Armani's new jacket but there was also an exhilarating sense of casual luxury,' wrote Patrick McCarthy in *Woman's Wear Daily*, the fashion industry's most powerful trade publication.

Stripped out and stripped back, Armani's style revolution was at once both casual and authoritative. Meshing the ease and comfort of sportswear with the elegance of tailoring, it spoke to a generation who wanted their clothes to do rather than just simply be. 'Manufacturers told me I was ruining the industry by promoting rumpled and wrinkled cloth. They couldn't manage to see the collection in terms of lifestyle, only good or bad

A gently draping double-breasted beige jacket and matching narrow trousers worn with a pale mushroom windowpane check crêpe blouse. Sometimes the continuity and gentle evolution of Armani's designs make it difficult to place in a specific time. Here, only the wide shoulder line gives a nod to 1988. If you owned this suit then, you could be wearing it still. Photograph by Neil Kirk.

fashion,' said Armani. Not content with unpicking the architecture of fashion, he even developed a colour palette, with 'greige' – a subtle combination of grey and beige – becoming a new word in the fashion lexicon. Clothes in innumerable shades of these two neutrals stalked the catwalk, and he pioneered a whole spectrum of subtle tones, stretching journalists' descriptive vocabulary as they waxed lyrical over 'nude,' 'cream' and 'biscuit', as well as 'sand', 'stone', 'earth-colour', 'mushroom', 'taupe' and 'tofu'.

In the eighties, Armani's aesthetic vision – the radical, soft shoulder silhouette, the monochrome palette – still sparkled with newness despite the advent of Punk in England and of the more geometric lines of Japanese designers in Paris. In addition, Azzedine Alaïa had brought back figure-hugging silhouettes, Jean-Paul Gaultier had put women back in corsets, and Versace was producing theatrical designs for rock stars on his catwalks. Despite this, John Fairchild, the influential publisher of *Women's Wear Daily* wrote in his book *Chic Savages*: 'There are six designers today who are true twinkling stars: Yves Saint Laurent, Giorgio Armani, Emanuel Ungaro, Karl Lagerfeld, Christian Lacroix and Vivienne Westwood. From them all fashion hangs by a golden thread. If the thread breaks, if they make a mistake, billions of dollars may be lost. All eyes are on these six: they show the industry where to go.'

In the early nineties, a classic Armani trouser suit, with wide lapels, simple button placement and tailored in refined fabrics, was the most coveted item in any woman's wardrobe worldwide. This herringbone design with double-breasted jacket and turn-up trousers exemplifies the uniform of the era. Photograph by Neil Kirk.

Armani would later reimagine his new tailoring concept by once again introducing padding to the shoulders whilst letting the rest undulate. A shoulder line, he says in retrospect, that could easily have been inspired by wartime silhouettes in the forties. 'It was certainly an imprinting,' he admits, 'an indelible impression that somehow re-enters into my fantasies just thinking about it.'

'The Armani jacket is perhaps the ultimate in soft, simple chic.'

VOGUE

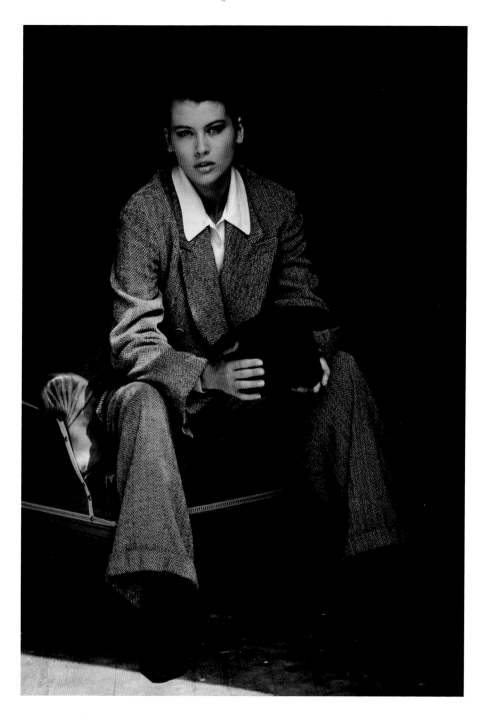

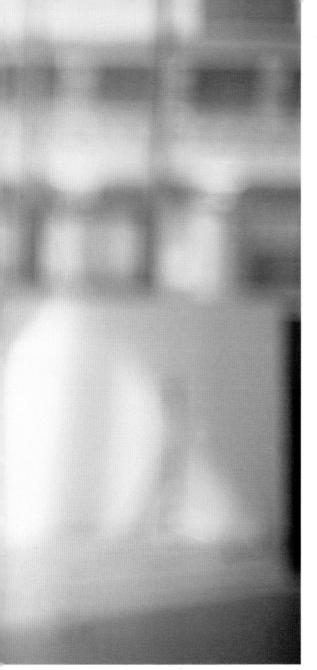

'EACH SEASON THE JACKET IS RE-EXAMINED AND RENEWED. IT IS REDESIGNED AND REPROPORTIONED AND GIVEN A THOUSAND VARIATIONS.'

FRANCA SOZZANI, VOGUE ITALIA

By the early eighties, women were 'dressing for success' in Armani's soft, de-masculinised jackets, like this white linen version photographed by Arthur Elgort on a cool Christy Turlington.

overleaf Scooping out the back, and adding a half-belt and wide flowing trousers feminises this classic white crêpe trouser suit (left). The masculine touches are collar and pockets. Photograph by Thomas Schenk. In a shoot by Manuela Pavesi for British Vogue, Carla Bruni (right) looks anything but masculine in a silk jacket and wrap skirt in palest peach.

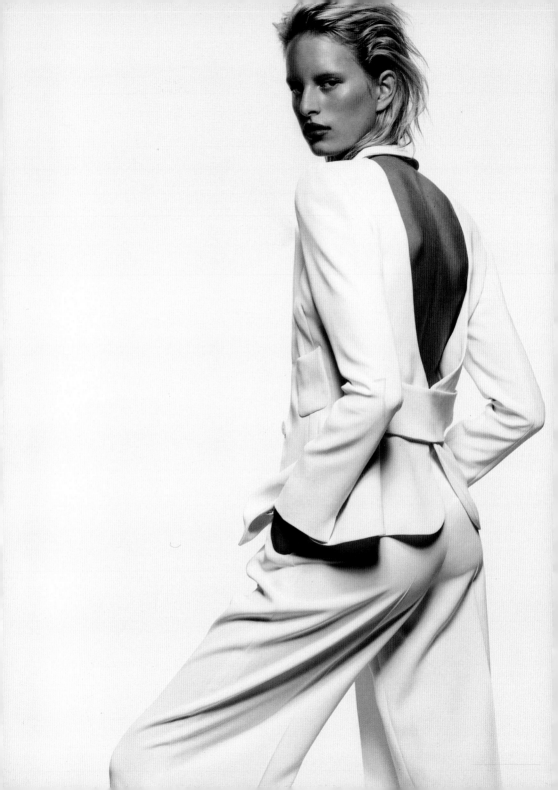

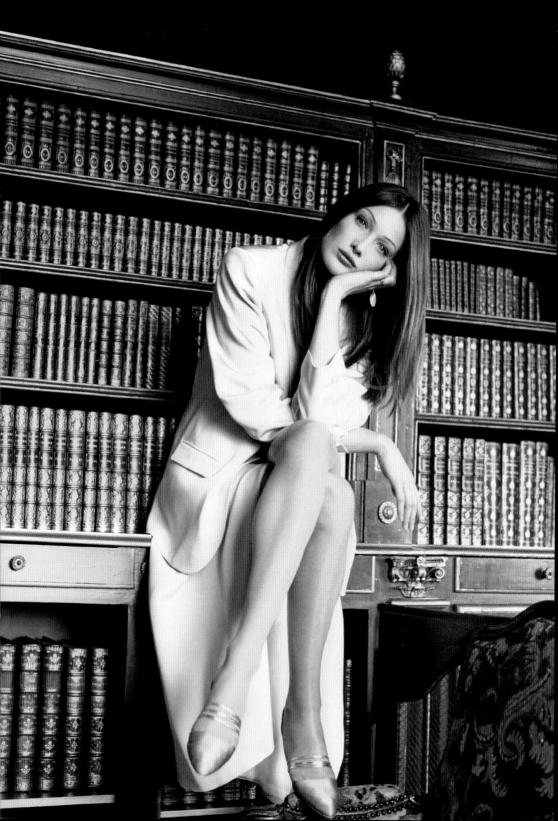

It was also a look that fitted perfectly with the new, more honed, athletic figure that women aspired to in the seventies and eighties, but also represented a timelessness that caught the attention of Hollywood. His preference for subtle, neutral colours stood against the immediacy of eye-catching trends. 'Colours and non-colours,' as the celebrated editor of *Vogue Italia* Franca Sozzani put it, 'it would be possible to discuss his muted palette until the end of time.'

Without doubt in the early nineties, a classic Armani trouser suit – soft and flowing, with bias cut or drooping collar, simple button placement and refined fabrics, such as crêpe or slubbed lightweight wool, and in a colour spectrum of peach through creams, dove greys, powder blues and navys – was the most coveted item in any woman's wardrobe, worldwide. 'The new woman in a trouser suit looks like a winner but she doesn't need to dress like a man,' wrote Sarah Mower in *Vogue* in 1992. 'Giorgio Armani believes anxiety over what to wear to work – Is it too assertive? Is it too feminine? – is yesterday's problem. He is inspired by a woman who has the courage to choose her own way of dressing and is confident in herself as a person. He likes exaggeratedly feminine clothes but feels they can be expressed in many different ways. "It is not something that can only be expressed in the design of a jacket and short skirt. A woman can be feminine even if she is wearing a pantsuit with a very masculine cut."'

Considering that Coco Chanel had made trousers acceptable for women in the thirties by wearing bell-bottoms on the Cote d'Azur – with Marlene Dietrich and Katharine Hepburn championing them later in Hollywood, not to mention Yves Saint Laurent's launching of *le smoking* in 1966 – it's surprising that the subject of women wearing trousers to the office or in the boardroom was still a subject for debate on the pages of *Vogue* more than half a century later. But it accentuates how forward-looking Armani's vision was and how narrow-minded it now seems for the short-skirted suit or dress to be entrenched, as it is in certain male-dominated industries, as the only business uniform

Armani has also transformed jackets into staggeringly beautiful, gossamer light and intricately beaded and sequinned designs for evening. These become future heirlooms, like this white and grey shirt, photographed by Tom Munro for Vogue *in 1997, woven with crystal and bugle beads and delicately embroidered with flowers.*

VOGUE

DEC
£2.90

**DOLCE &
GABBANA**
GLAMOUR KINGS

SHOW GIRLS
THE NEW FORCE
IN BRITISH ART

**PERFECT
PRESENTS**
MEN GO XMAS
SHOPPING

STAR
MODELS
FASHION'S FAVOURITE FACES

for women. It is an irony, too, that in some management situations wearing trousers is considered less professional-looking, when women have so often been quoted as saying that in Armani suits they get 'taken seriously'. All sorts of women felt protected in his clothes, seeing them as talismanic in some way – including Italy's most renowned actress: 'The most important thing Armani clothes give me is a kind of security,' says Sophia Loren. 'When I have to face an audience, God knows how many doubts I have, and when I wear his clothes, I have no more doubts.'

Certainly the sight of Michelle Pfeiffer and Jodie Foster in simple tuxedo trouser suits for their Oscar appearances had a ricochet effect that was soon reflected in sales and in company boardrooms the world over. 'The need to own an Armani jacket stole over me gradually,' wrote Dodie Kazanjian in a three-page *Vogue* paean to the Armani jacket in the mid-nineties, 'so gradually that by the time I became fully aware of it I already wanted one quite a lot. A lot of women I know are addicted to its fluid, understated, soft, versatile and blissfully comfortable style and a lot of famous women I don't know have been photographed wearing it.' Kazanjian followed this with what seemed an interminable list, including Anjelica Huston, Winona Ryder, Jodie Foster, Ali McGraw, Lauren Bacall, Sherry Lansing, Cindy Crawford and Annette Bening. According to Kazanjian, when Ali McGraw's Malibu House burned to the ground, the only item she truly missed was her twelve-year-old Armani tuxedo jacket. So much so that she went out and bought a replacement. To some they're like paintings, artistry to be collected. The writer Joan Juliet Buck has twenty of them.

Always refusing to change his steady evolution in design in favour of shocking or surprising the press and buyers just to make headlines, Armani has confounded his critics on occasion with jackets transformed from the practical or daytime crêpes, linen weaves and cashmeres to staggeringly beautiful, gossamer light and intricately beaded and sequinned designs for evening. 'Putting a focus on the person and not the clothing and finding the balance' is how he sees the

point of his work and this applies as much to evening wear as it does to daywear. 'I've always adored precious materials and for me they're most important for evening,' he said about his 1999 spring/summer collection but it could easily apply to many collections since. 'I've chosen sparkling designs with a hint of the Orient on delicate materials and veiled embroidery with tulle. My black comes adorned with light reflective embellishments such as crystal beads and sequins used to create intricate geometric patterns.'

'In two decades of watching Giorgio Armani's shows,' says Lisa Armstrong, 'I can't remember him ever wavering significantly from his ideal, even if that makes him sometimes seem out of step with other designers. But of course he never is out of step with real women because there is always a customer for a beautifully cut jacket or trousers.' 'Before Armani, women's trouser suits were a harder-edged affair – the YSL influence,' continues Armstrong. 'He gave them a luxurious yet minimalist northern Italian stamp. His clothes really are timeless. He has incredible focus on His Look, more than most designers – maybe because more than many designers, he actually invented a way of dressing, that's partly what places him among the greats.'

Armani jackets age differently from other clothes. While trends slip out of style, Armani jackets simply get exhausted from overuse. However, unlike his fellow pioneers Armani's considerable eye for style wasn't always trained on the fashion world. It may well have been his destiny, but his love affair with fashion was, in reality, a gradual but happy accident.

Occasionally Armani amuses himself with bursts of colour almost to defy those who would criticise his seemingly endless neutral palette. Here a flowing coat and mohair trousers in vibrant scarlet are tailored yet fluid. The twist is in the splash of colour. Photograph by Kim Knott.

'Clothes so free and flexible – it's time
to be yourself, to suit your looks.'

VOGUE

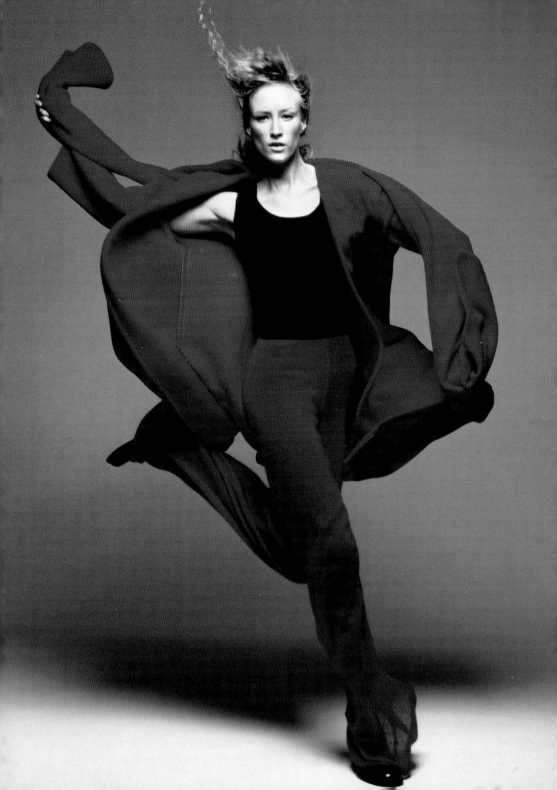

'MEN LIKE ARMANI ARE SO RARE
THAT WHEN ONE EMERGES, EVEN
A BLIND MAN NOTICES.'

NINO CERRUTI

MADE IN MILAN

'I remember the enormous rooms full of looms that never stopped working. And noise. Though people were talking, they didn't seem to hear each other. It was very hard work and I never thought I'd fall in love with it. Then, little by little, it became a passion.' Giorgio Armani recounted these first tentative steps in the industry – working at Nino Cerruti's textile factories in the mid-sixties – to Martin Scorsese, who filmed the designer for a specially commissioned documentary called *Made in Milan*. 'Fabric was my introduction to fashion,' said Armani, as he was shown sifting through a sea of materials, pointing out to an assembled mass of assistants exactly what he wanted. Filmed in 1990, it was the only documentary short the director ever made, and it followed its subject as he prepared for a prestigious show in his adopted city.

Armani sketching at his desk in the seventeenth-century palazzo in Via Durini 24; the design studio remained there until 1982 – the year Armani appeared on the cover of Time magazine.

Not every designer commanded this treatment, but Armani was different. As a new decade dawned he was the darling of Hollywood, and unquestionably the most important fashion figure in the world. He had already graced the cover of *Time* magazine, received a lifetime achievement award from the Council of Fashion Designers of America, an Order of Merit of the Italian Republic, and an *Ambrogino d'oro*, the highest honour of the Municipality of Milan. 'Milan is my chosen city,' said Armani, 'where I live and work. It's a city that allows you to express yourself, and respects you if you have something to say. The beauty of the city is in harmony with my style of work, my way of life, my way of seeing things.'

It's a far cry but a short journey from the picturesque province of Piacenza, where Armani grew up as a child of war-torn fascist Italy. Born to Ugo and Maria on 11 July 1934, the young Giorgio's life was a world apart from the glamour of catwalks and Hollywood. A fertile, provincial city in the Emilia-Romagna region of northern Italy, Piacenza's strategic importance as the home of river crossings over the Po and Trebbia made it a regular target for Allied bombing campaigns during the Second World War. 'Bombs were constantly falling down on us. I witnessed the deaths of two of my friends in a bombing raid,' remembered Armani, who himself spent forty days in

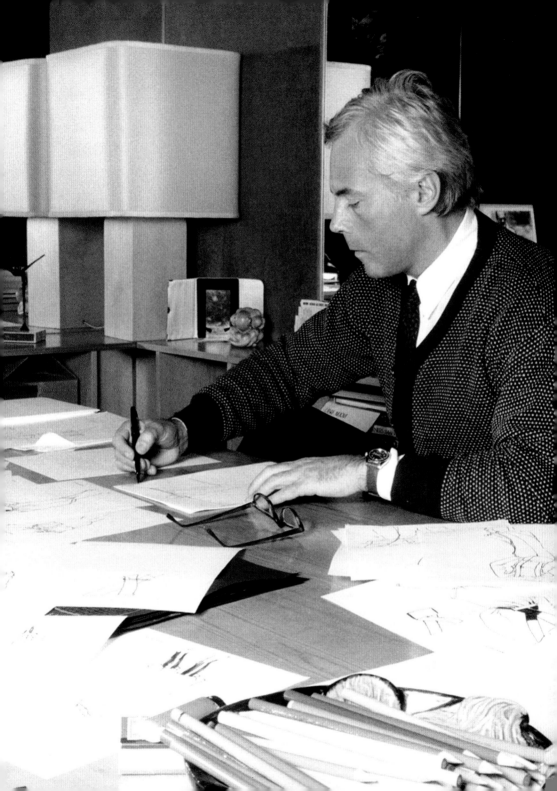

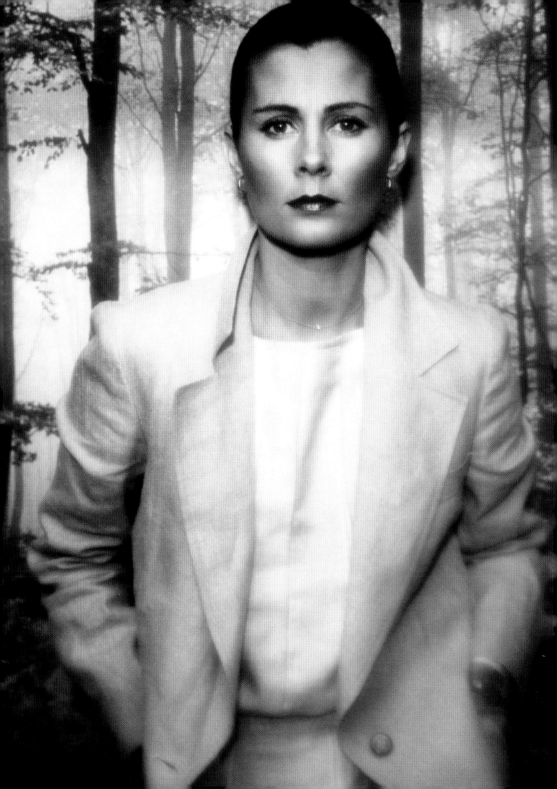

hospital after a foolish 'boy's own' accident with gunpowder following an all clear that claimed the life of another of his friends. When the war ended, Giorgio's father Ugo, who had served as a civil servant in Mussolini's National Fascist Party, was sent to prison as punishment for his complicity. When he was released, he moved to Milan to find work, leaving his wife in charge of the family.

The middle child of three, Giorgio was the shyest and most reserved of his siblings. Sergio, his elder brother by five years, was the quintessential first-born male. 'Tall, sturdy, reckless and daring,' is how Armani's biographer Renata Molho describes him in the 2006 *Being Armani*. Rosanna, born in 1939, a model, actress and journalist, was an elegant beauty whom Armani adored. But it was Maria who was the greatest influenced on her son. 'She was a wonderful mother,' Armani recalled. 'She never let us feel as if we were underprivileged. She made us sports shirts and shorts with a khaki fabric that at the time was called "coloniale" and we looked every bit as good as our wealthy friends. Perhaps my love of sober, discreet, understated clothing came, subconsciously, out of that childhood memory – out of my mother's ability to send us off to school well dressed, with what little she could afford. She found her own style and remained faithful to it. Her original and dignified idea of elegance is expressed in a kind of uniform: it's more mental than physical. My mother was my inspiration in the idea that ethics and aesthetics should be a reflection of the other. She expressed a lot of dignity, a feeling that has characterised her whole life, by which I was deeply affected.'

Early on, Giorgio Armani's older sister Rosanna helped her brother's career; first posing for pictures he had hastily put together for a portfolio for an interview with Milanese department store La Rinascente, and later, as here, modelling his designs in advertising campaigns. Photograph by Aldo Fallai.

By the end of the forties, Ugo Armani had enough money to move the family to Milan, so they began a new life in the historical Ticinese quarter, a 'small area' according to Armani, 'in a part of Milan that was poor.' At this point, Giorgio was a quiet but popular adolescent, with an elegance that belied his status and a penchant for photography and for helping his friends look stylish. But despite the maturing of his creative instincts, Armani himself had no idea of his

future. 'At the beginning there was no fire in my belly for fashion,' he later recalled. 'I really didn't want to do fashion at all.' Instead he embarked on a career in medicine at the University of Milan. 'I wanted to be a country doctor, like the ones you read about in novels who take care of the poor.' In his third year of studies he left to join the army, where his medical training saw him transferred to the infirmary in Verona. Still a young idealist with a head full of Hollywood films, his romantic picture of medical and military life clashed markedly with the altogether grimmer reality. A major flu epidemic landed the young trainee with over seventy stricken soldiers to care for, destroying his rose-tinted vision of a prospective career.

At the end of his military service, with the support of his parents, he decided on a new direction. A friend knew of an opening in the advertising department of her own workplace and, having convinced his sister to pose for his portfolio, he began what turned out to be a fruitful and fulfilling six-year employment at the main department store in Milan. La Rinascente, christened after the war to mean 'She who is born again', would, rather fittingly, be the birth of a new and lucrative life for Armani. Armani's arrival coincided with a creative boom in Italian fashion and, as a consequence, La Rinascente. Milan, too, was becoming a hub of cultural and economic regrowth. Historian John Foot described it as 'the capital of Italy's economic miracle of the 1950s and 60s', and few industries felt this effect as much as fashion. Seeking to distinguish themselves from their earlier French influences, Milanese fashion houses began to use their considerable knowledge and infrastructure to marry the principles of haute couture and prêt-à-porter. Born as much of necessity as art for an expanding, modernising population, great clothes were no longer the preserve of the elite.

Armani's greatest influence was his mother, Maria, here with Giorgio on holiday. 'She was a wonderful mother,' he has said. 'She was my inspiration in the idea that ethics and aesthetics should be a reflection of the other.'

Initially an assistant window dresser and photographer, Armani was swiftly moved to the fashion buyers' department and eventually put in charge of men's apparel. With the scope of the Italian fashion scene broadening, Armani began importing bolder and bolder items.

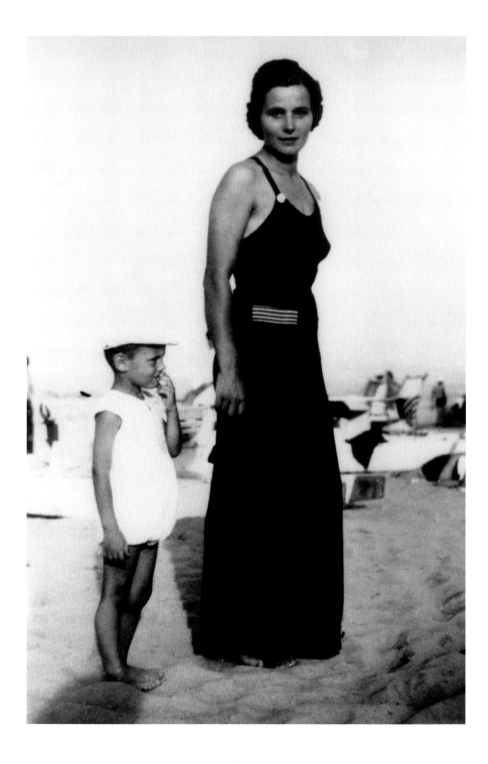

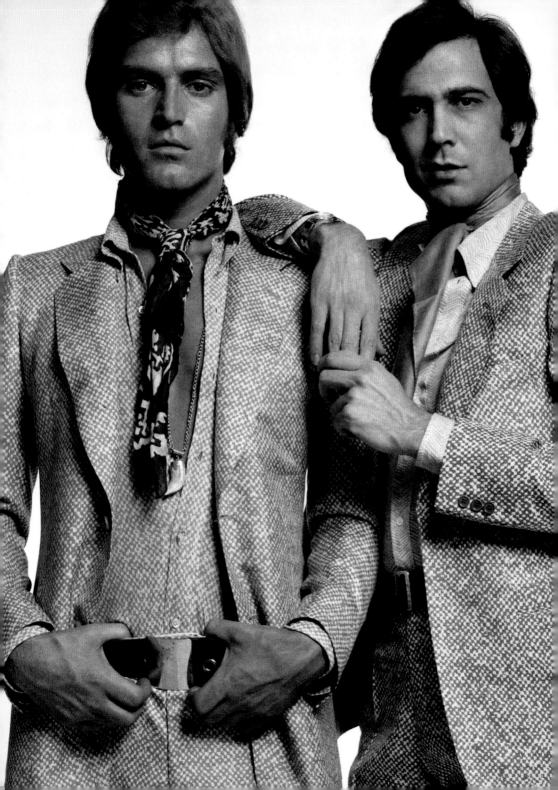

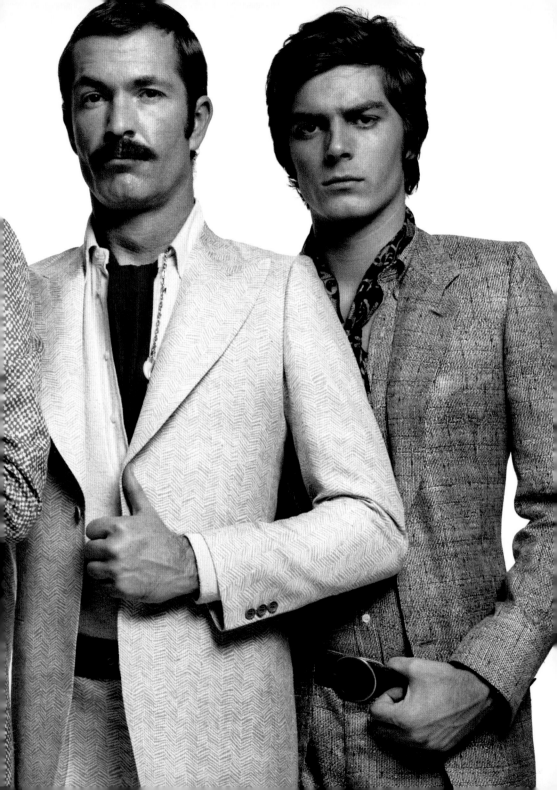

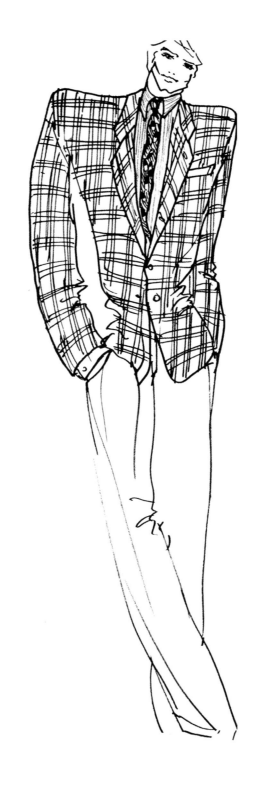

And he sourced them from further afield than the Italian market was accustomed to – India, Japan and, of course, England. 'We used to travel to London for the influences, to see the shops, to learn. I remember seeing some yellow cardigans in a small boutique and bringing them to La Rinascente and everyone thought I was insane. Yellow cardigans were what the Duke of Windsor was about, they were not something for the average man.' Though he admits he was 'terribly afraid of getting it wrong', these early successes gained him some standing within the industry and brought him to the attention of Nino Cerruti.

A sketch by Giorgio Armani of a Prince of Wales check jacket, with lapels much wider than was traditional, for autumn/winter 1979. As a teenager he would go to Milan to have his suits made by a tailor. Even then, notes fashion writer Anna Piaggi, 'he had quite a hand for choosing fabrics, unusual bird's eyes, houndstooths, slightly different chevrons and subtle colourings.'

previous pages In 1964 Armani left Rinascente to design for Hitman, Nino Cerruti's already well-established menswear line. Almost immediately, his designs were being lauded. By the time of this seventies advertising campaign, he even gets a named credit as the designer. Photograph by Gianpaolo Barbieri.

The heir to a textile dynasty and only three years Armani's senior, Cerruti was already an established figure in the fashion world after his revelatory Hitman line was launched in 1957. Pivotal in the marriage of industry and fashion, he was the first to introduce successfully a tailored, ready-to-wear range for men. He and Armani shared similar creative sensibilities, a love of film and a desire to design for Hollywood. In 1964 Armani left Rinascente to work on Hitman.

Although his eye for style had impressed, the thirty-year-old Armani was still a design novice, so Cerruti sent him to the factory to learn his trade. 'When I was starting out, I'm not ashamed to say I would sketch over fashion illustrations or what they call "maquettes" of Yves Saint Laurent's. I couldn't draw the human form. It was very difficult for me. Some of my early drawings were very elementary, very basic. But slowly, I got better.' Within two months of training his designs were being noticed and, though only a select few made it into those early collections, the genie was out of the bottle. 'He would've made a name for himself in any case,' Cerruti would later say when charged with discovering him. 'Men like Armani are so rare that when one emerges, even a blind man notices.'

By the seventies his stock had risen to such a degree that the label began promoting his designs by name. 'Hitman by Giorgio Armani' appeared on advertisements, including a notorious Oliviero Toscani campaign, famous for being perhaps amongst the first in the fashion world to shun the product in favour of an avant-garde aesthetic or social commentary. 'The ad featured a close up of a long haired man. You can see the hair moving slightly, but not his face,' Armani recalls. 'At first everyone said, "Armani, you're using a photograph that doesn't show the clothing. No shoes, no fabrics. We make fabrics, we make clothing!" Nowadays you can see a lot of fashion advertising like this, but at the time it was really innovative.'

It was an exciting and liberating time for Armani. Trusted implicitly by Cerruti, he also began designing unaccredited collections for other fashion houses. 'Even if his name was not officially attached to the work, everyone knew the applause was for Giorgio,' wrote Molho in *Being Armani*. Armani became aware of the creative limitations of his role, but did not consider branching out on his own. He'd fallen into fashion and ended up with a stable job and a great wage, why would he jeopardise that? The very idea of new designers going into business for themselves was almost unheard of anyway. The *stilisti* were a relatively new concept. 'To tell your friends, or your mother "I'm going to be a *stilista*" was something totally mysterious,' says Armani. 'You couldn't convince them it was a good career.'

Catwalk pictures from Armani collections in 1984, 1988 and 1992 show his ever consistent design message encapsulated in a parade of innovative jackets: broad-shouldered, shawl-collared or cardigan-shaped then worked in pinstripe wools, crêpes or plaid linens. Photographs by Michel Arnaud and Sean Cunningham.

Once again fate intervened. For all the confidence his meteoric rise had engendered, the naturally shy and reserved *stilista* still needed a push, and it came courtesy of Sergio Galeotti. Armani had met this tall, exuberant social butterfly in 1966, and though the two could hardly have been more different, the attraction was instant

'Armani injected the ease of
sportswear into tailored suits.'

SUZY MENKES

and profound, and they completed each other, both professionally and personally. 'Whatever I did in work was done for Sergio. And Sergio did everything for me. So that was the heart,' Armani told *Vanity Fair* in 2000. Were it not for the relentless pushing of his Tuscan partner, the Armani empire of today would not exist. 'He was already earning a lot of money but he was hesitant of starting a business of his own,' Galeotti remembered. 'It took me a whole year, but I finally managed to persuade him.' Armani agreed. 'When we embarked on our company, he was often the one with confidence. He had complete belief in what we were doing.'

At the turn of the decade the two moved to an office in the Corso Venezia, now the centre of the famous Via Montenapoleone fashion district. After five years freelance, on 24 July 1975 they finally cut all ties and threw themselves fully into the unknown, founding Giorgio Armani S.p.A. from a small two-room office, with a staff of three: Giorgio, Sergio and student secretary Irene Pantone. 'We had so little we had to let her study on the job,' said Galeotti. The operation was so small that, with no extra income, Armani had to sell his car – a blue Volkswagen Beetle – to meet the costs.

While Armani concentrated on the inaugural collection that would present his brand, and name, to the world, the outgoing and ebullient Galeotti embraced the part of manager, salesman and businessman extraordinaire, though in reality he had little experience. He'd arrived in Milan as an architectural draftsman before becoming a fabric buyer. Armani would later admit it was largely bluff. 'To the eyes of the world we encouraged the idea that Sergio was the big sales guy in charge of the company, and I was the creative.' But Galeotti seized this role: from very early on, for example, he would strenuously demand buyers fulfil the minimum order; this enraged American department stores who were used to picking up small orders and, occasionally, copying – a tactic of which Galeotti was all too aware.

Armani's style revolution was at once both casual and authoritative. Both suits pictured here show Armani's seemingly classic tailoring given his signature modern twist of softer lines, ease and comfort. Photograph by Eamon J McCabe.

overleaf *A double-breasted wool suit in sharp lozenge/pinstripe pattern, jetted pockets and no vent with inverted pleat trouser, photographed by Anthony Crickmay in 1980. Armani's success in menswear was immediate and meteoric from his first collection.*

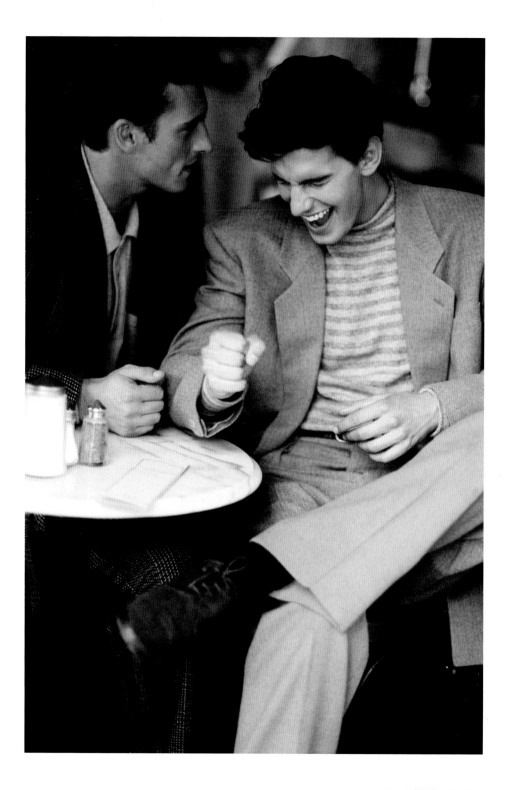

'HE WAS DOING
FOR THE JACKET
WHAT OTHERS
WERE DOING
FOR PHILOSOPHY,
ARCHITECTURE
AND ART.'

DODIE KAZANJIAN, VOGUE

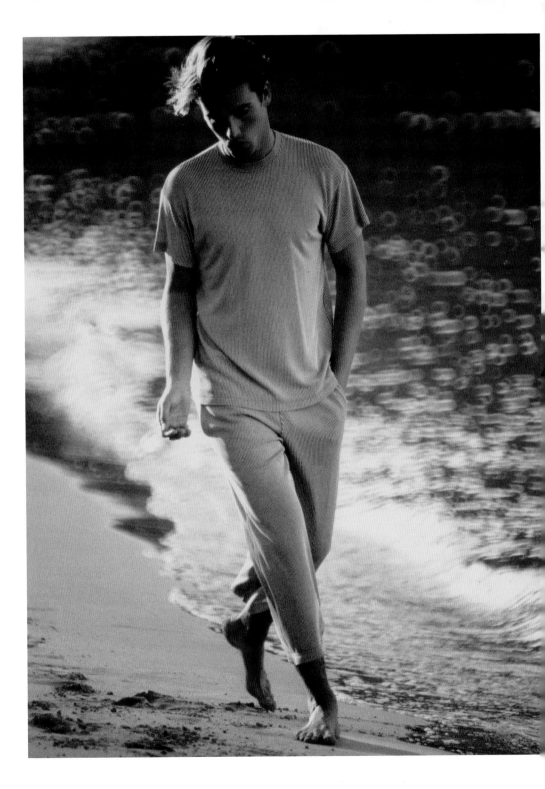

Within a mere three months of start-up, the new house of Armani launched its first menswear collection for the spring/summer season, in its own tiny showroom. Three months later, the first womenswear collection debuted, this time in an old Milanese restaurant. By the time the autumn/winter collection was presented, it was in the halls of the Palace Hotel. 'I hadn't just jumped into the void, coming up with ideas off the cuff,' said Armani. 'I set out with some very clear ideas about what I wanted to see women wearing. It seemed to me they had been rendered ridiculous. Loaded with gimmicks and gadgets and bedroom suggestiveness. Working women's lives were no different from the lives of men, and they needed to dress for the same purposes.'

According to Armani it took 'at least four seasons' for him to find his true voice as a designer, and what we'd recognise now as his trademark style; but to those who were there, those early shows still bore the hallmarks of what was to come. 'The collection was already a beautiful thing to behold. It looked different,' wrote Gisella Borioli, then of *L'Uomo Vogue*. 'The use of materials, the deconstructed look ... it all worked very well.' His ideas were an instant hit with the new young professionals – people with no use for stuffy ornate fashion and accustomed to more practical, lived-in attire, to whom Armani provided comfort with a dash of elegant *savoir faire*.

A year from its first collection, Giorgio Armani S.p.A. made $500,000 on its initial investment of just $10,000. The first international outlet was launched in 1976 in, of all places, Barneys of New York. 'America understood the importance of Armani before anyone else,' wrote Natalia Aspesi. 'It was a country with a pioneering spirit, where women suddenly found themselves in the workplace where they needed a new kind of armour.' In 1977 Armani worked with Borioli and Toscani to display his latest collection in *L'Uomo Vogue* featuring short-haired athletic models, many of them real soldiers, plucked from the Perrucchetti barracks where the shoot was set.

From the beginning, Armani's designs were popular with young professionals who wanted clothes that were stylish, comfortable and easy to wear. Armani's relaxed t-shirt and pull-on trousers yet again anticipated a fashion to come, decades before tracksuit bottoms became everyday dressing. Photograph by Eddy Kohli.

overleaf *'A woman can be feminine even if she is wearing a pantsuit with a very masculine cut,' says Armani. It's true of this wool gabardine double-breasted jacket and wide-leg trousers, worn with a white silk shirt whose oversize collar spills over the matching high-buttoned waistcoat. Photograph by Andrea Blanch.*

'I WANTED
TO DRESS THE
WOMAN WHO
LIVES AND
WORKS, NOT
THE WOMAN
IN A PAINTING.'

GIORGIO ARMANI

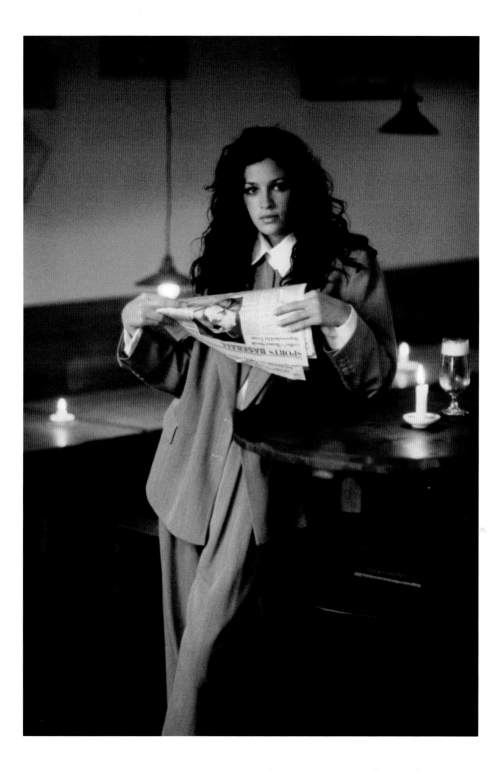

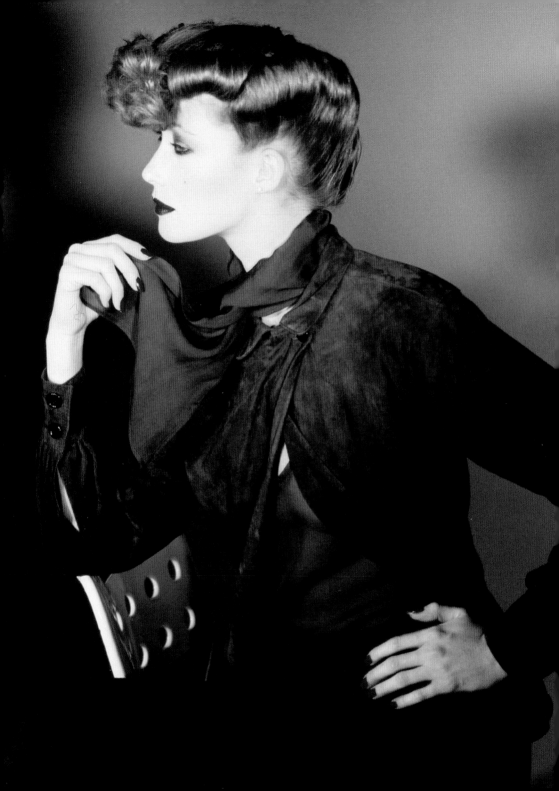

It was a revelation at a time when most modern fashion was still focused on a skinny, somewhat effeminate silhouette for men with long hair and beards. From that moment on, this new clean-shaven, muscled body type became the fashionable ideal for the next four decades, in no small part thanks to Giorgio Armani.

Success was immediate and meteoric, but the company was growing too fast and the demand on their manufacturing became too great, so Galeotti made a deal with Gruppo GFT, a Turin-based textile group, that gave the company a financial cushion. 'At the time we could've purchased the Giorgio Armani Company,' said Carlo Rivetti, a member of the Rivetti dynasty who founded and owned Gruppo GFT. 'Instead we decided, in part out of respect, to purchase the fabric warehouse.' An oil crisis and political turmoil had forced even more businesses to move into Milan as the only place with the requisite textile infrastructure, and the city became firmly established as the fashion capital of Italy. By 1979, Milan's fashion business turnover had eclipsed that of Paris for the first time.

In the same year Armani started his first diffusion line, a more affordable range named Le Collezioni, and founded the Giorgio Armani Men's Wear Corporation USA. He also hired Gabriella Forte as manager of operations in the US. His first show there, at Saks Fifth Avenue, was a roaring success, attracting ten times the audience they'd expected, and requiring the hasty arrangement of extra shows to meet the demand. Sergio Galeotti rented out Studio 54 to celebrate.

As his success grew, Armani stuck to the principles that had inspired him: 'The "great designer" of luxury fashion working to bring the same fashion to the less wealthy as well,' as he put it. 'We began to experiment with menswear collections made primarily in denim.' It targeted a younger audience, with less purchasing power, more closely linked to the world of casual wear. They named it Emporio Armani, which translates as Armani's general store.

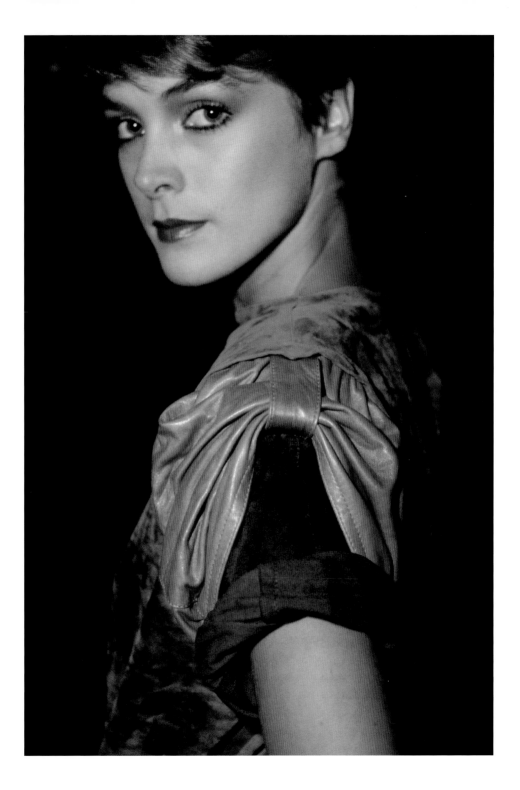

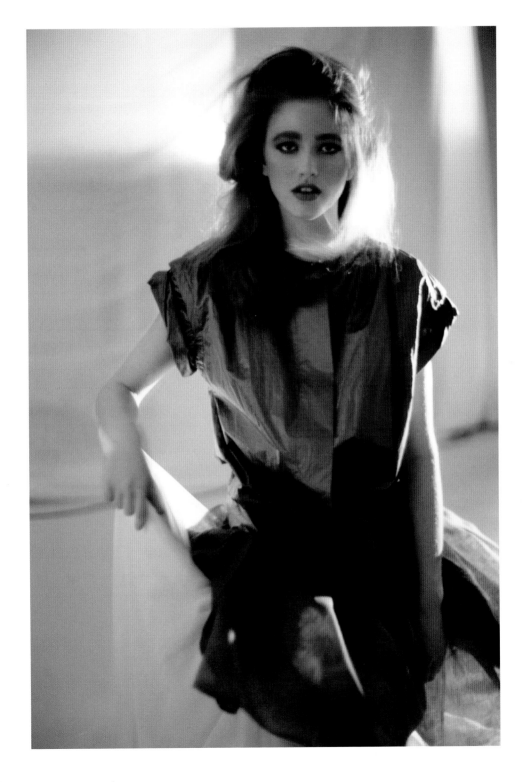

Emporio opened in 1981 and in a mere two years had 90 stores throughout Italy. Armani was now a superstar of fashion. The press called him *Re Giorgio* – 'King Giorgio'; he graced the cover of *Time* magazine and had his portrait painted by Andy Warhol. At this point he brought in Rosanna to work at the company, though it was outwardly Galeotti's choice, of course. 'I was happy that the offer came from Sergio,' she said. 'In part because Giorgio would have had a hard time asking me, and in fact probably never would.' At the same time they moved into a new office and home at Via Borgonuovo 21, the address that would become Armani's stronghold for the next 30 years. The classical palazzo was redesigned by his old La Rinascente colleague Giancarlo Ortelli and fittingly stripped (or deconstructed if you will) of its pompous awnings and columns and transformed into a space more befitting King Giorgio.

By 1985, the year that marked ten years since the inception of Giorgio Armani S.p.A., the company's turnover had skyrocketed to $300 million. But it was not a year for celebration. On 14 August, Sergio Galeotti died. Though announced as a heart attack, the true cause was AIDS, but such was the scurrilous and misinformed perception of the disease in the mid-eighties that Armani felt honour bound to protect the man he loved from the indignity of gossip, even in death.

Now, without Galeotti, Armani had to be more than just a designer, to develop a business mind and public attitude, all whilst dealing with the most devastating and personal of losses. That he could, and did, is testament to his extraordinary work ethic, but then, for a man who lives by the credo 'my work is my life', there was never a choice. 'I found myself obliged to imagine a different nature within myself, a twofold personality,' he said. 'I managed to enter into the spirit of the other role, the job of an entrepreneur who judged a collection from a commercial point of view.'

Armani has often looked at Eastern and historical dress for new ways of construction and fabrication. This single twist of frogging on a cream evening shirt with fluted cuffs is an example. Frogs are often used on oriental tops with a mandarin collar to keep the two sections of the front closed, and the device was also used historically to decorate military uniforms. Photograph by Neil Kirk.

overleaf A burnt-orange suede cardigan jacket and soft men's waistcoat, worn over perfect charcoal trousers and a biscuit chiffon Peter-Pan-collared shirt, photographed by Alex Chatelain (left). Bowler hat, gloves and brogues complete the masculine-feminine Armani picture. Armani's grey/white linen twill (right) cut in a swathe with draped lapels and patch pockets, photographed by Paolo Roversi in 1984. During this decade, known in the fashion world as 'Il Made in Italy', Milan became firmly established as the fashion capital of Italy and Armani was its king.

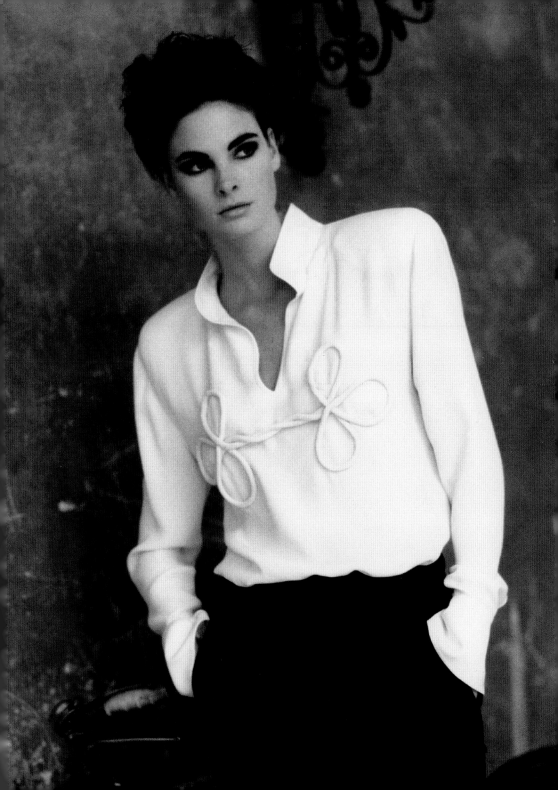

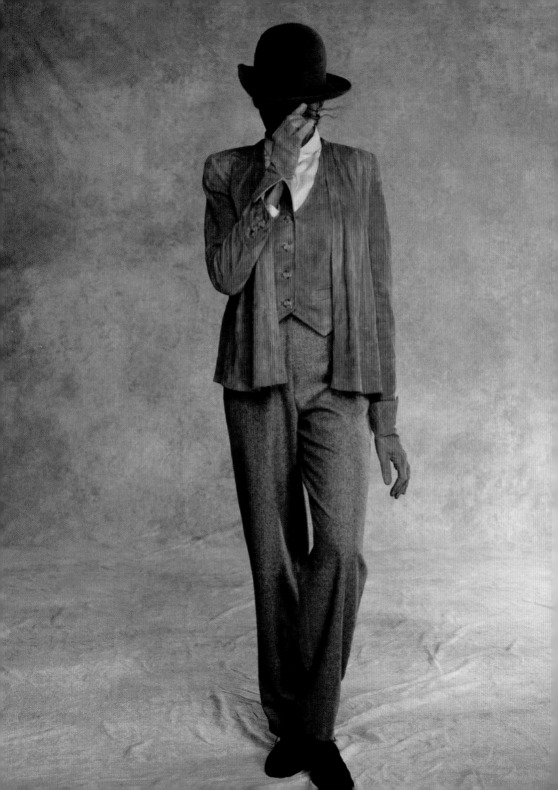

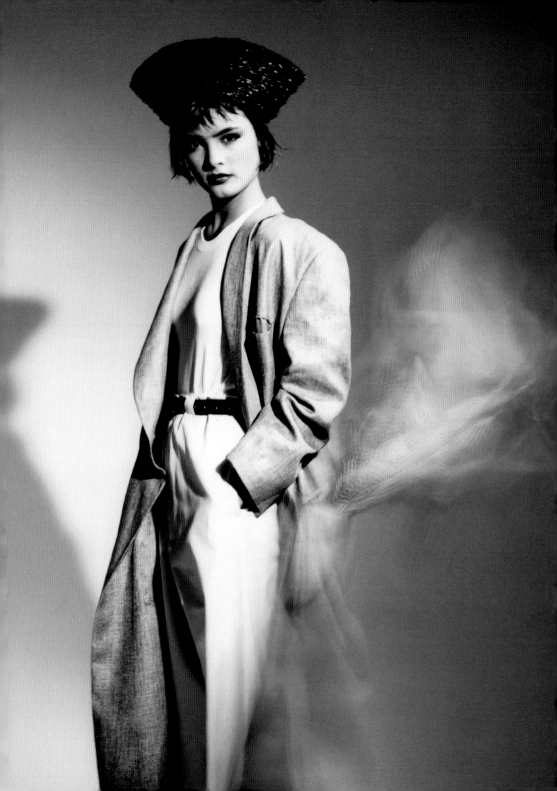

'STYLE WITHOUT EXCESSIVE DESIGN.'

GRACE MIRABELLA, VOGUE

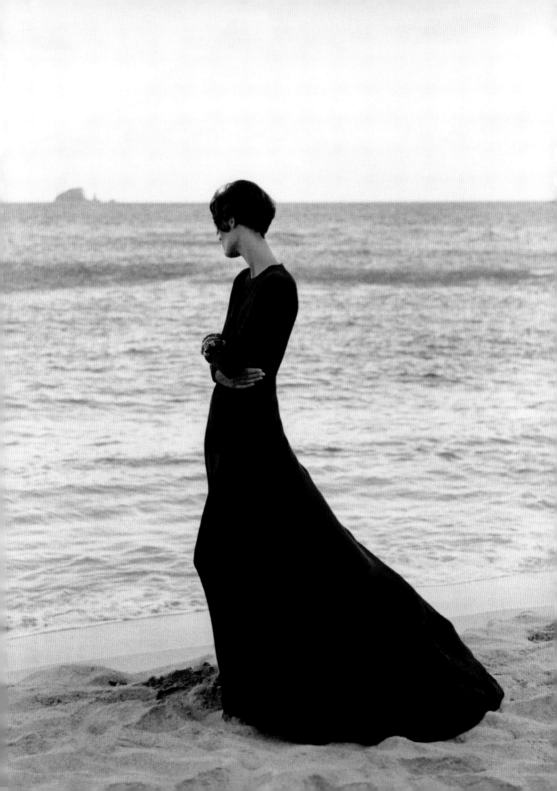

For the next year Armani studiously learnt the demands of the new role. When a few apprehensive figures left, he restructured the company, moving Rosanna and his niece Silvana (the daughter of his brother Sergio) into more prominent positions. Exceptionally discreet, his love life has never again been public and he admits that his sense of duty has always prevailed even at the expense of relationships with others. Family, of course – particularly in Italy – is different, as are the few loyal friends whose trust and affection he shares. Irene Pantone, that first student secretary, stayed with him and works in the company to this day, such is the loyalty he inspires. Galeotti and Armani had always treated Armani S.p.A. as a family business, and as the company increasingly morphed into a corporate Goliath in the wake of Galeotti's death, the designer strove to keep his inner sanctum familial and the emotional core, once provided by his partner, intact.

Far from the prophesied decline, the company's fortunes had soared by the late eighties. They became self-sufficient, a new breed of fashion house reliant on neither suppliers nor banks. More stores opened as Emporio took on a life of its own and diffusion lines for underwear, jeans and 'Bambinos' catered for the ever increasing demand. In 1990, eight years since his *Time* magazine cover, an entire week was dedicated to celebrating Giorgio Armani in New York. The Fashion Institute of Technology held an exhibition of over two hundred photographs chronicling the effect of his fashion revolution in menswear. *The Wall Street Journal* heralded him as the 'conqueror of Manhattan' and the Museum of Modern Art premiered Scorsese's *Made in Milan*. Scorsese had directed the first television commercial for Emporio Armani in 1986, as well as a second, award-winning spot for Armani Perfume in 1988. The two had bonded over their shared love of film, an industry on which both would continue to have a profound effect.

Helena Christensen photographed by Sante D'Orazio on the shores of Lake Como in an impeccable dressing gown coat of velvet and satin.

previous page *'The flawless simplicity of flowing navy crêpe,' wrote Vogue in 1989 of this picture, extolling the virtues of luxury, calm and volume in a silk crêpe evening dress. Photograph by Patrick Demarchelier.*

overleaf *As a new decade dawns, Armani is the darling of Hollywood and the most important fashion figure in the world, whose designs can dress the stars in glamorous gowns, not just jacket and trousers. A curved black silk crêpe bodysuit (left) edged in sparkling silver with a broad black chiffon centre panel worn over a silk crêpe wrap skirt, split to the thigh. Photograph by Steven Klein. Eric Boman photographs poolside glamour (right) with a silk wrap dress, plunging to the waist at the back and sparkling with rhinestones.*

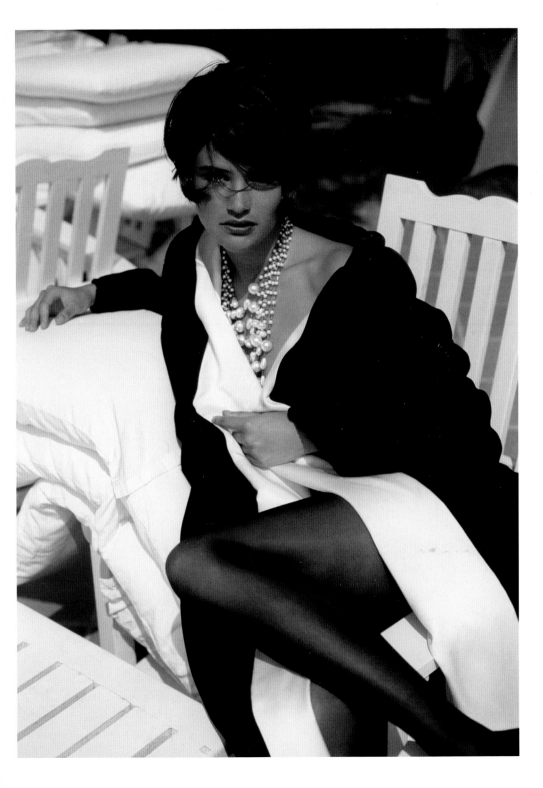

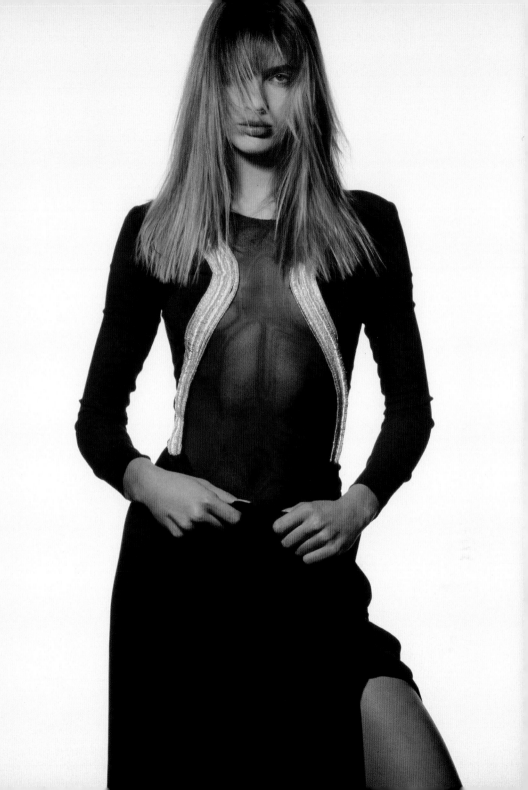

'LIFE IS THE MOVIE, AND MY
CLOTHES ARE THE COSTUMES.'

GIORGIO ARMANI

FROM HERE TO
MODERNITY

The opening strains of 'The Love I Saw in You Was Just a Mirage' by Smokey Robinson and the Miracles play, as a beautiful, shirtless Richard Gere saunters over to his lavish Los Angeles wardrobe and carefully picks out four impeccable unconstructed jackets. He lays them side by side on the bed, as neatly and professionally as a stylist might, before rhythmically opening and closing the drawers in his dresser, allowing the camera to linger lovingly over each new row of perfectly pressed shirts. Gere is Julian, the anti-hero of Paul Schrader's 1980 film *American Gigolo*, and this ritual preparation is intended to convey the high aesthetic standards he strives for. Everything on display has been designed by Giorgio Armani. Before the scene ends, the camera sweeps adoringly over a delicately arranged pile of suits, shirts and ties, all matched and exhibited to perfection. It's as much a fashion advert as a movie scene, and so it proved to be. Before the decade was out, Armani was Hollywood style.

Released in 1980, American Gigolo made a star of Richard Gere, and introduced Armani to Hollywood and hence global fame. In the film, the camera highlights all of Gere's (Julian's) impeccably designed wardrobe, each shirt, jacket and softly elegant coat displayed to perfection. Gere became devoted to Armani. 'I don't know any other designers.'

As a boy, the young Giorgio had been enraptured by cinema, the films of Blasetti, Fellini and Antonioni providing escapist comfort to a shy, creative child in the bleak aftermath of the Second World War. Imaginative storytelling also nurtured his early talent for design. With his brother, he would stage home-made puppet shows for his family, and while Sergio acted, Giorgio created the sets and characters from bits of cloth, wood and whatever bric-a-brac he could lay his hands on. On joining the army in early adulthood he romantically imagined himself as if he were a character from the 1953 film *From Here to Eternity*. 'I even brought my tennis racket with me,' he recalled, as if even then he preferred to see life through a camera lens.

In 1999 he financed and produced *My Voyage to Italy*, Martin Scorsese's acclaimed four-hour documentary on the Golden Age of Italian cinema, and in 2002 Armani's grand Teatro in Milan hosted an evening of newly restored classic Italian films. But if it was Italian cinema that had greatly influenced Armani, it was American cinema that Armani would later infiltrate and greatly affect. Starting with *American Gigolo*.

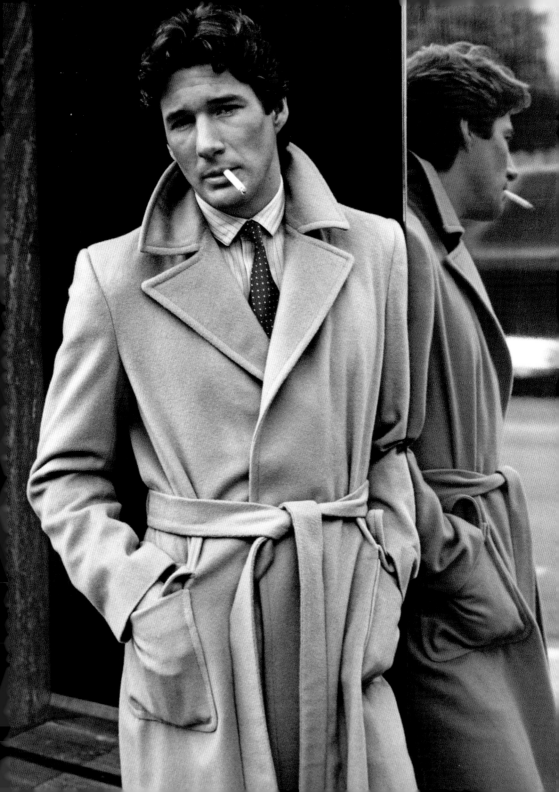

In 1979 Armani and Galeotti were preparing for a their first international non-couture line when John Travolta's manager, Bob LeMond, suggested that they dress the star for his new film. LeMond was an Armani devotee and had persuaded Paul Schrader that the designer would be a perfect stylistic fit. Though Travolta had even journeyed to Milan to pick out suits, he pulled out of the role at the last minute, and in his stead the part went to Richard Gere.

American Gigolo not only launched the career of Gere, but also introduced Armani to Hollywood, and consequently the wider world, though Hollywood had had its first glimpse of Armani the previous year, when Diane Keaton accepted her Academy Award for Best Actress wearing a trademark greige unconstructed jacket. Climbing the stairs to received her gold statuette in a crumpled linen jacket, shirt and skirt ensemble were revolutionary steps at an occasion usually overrun with debatably bad taste, frills and over embellishment. This looked like daytime. Armani interpreted it as 'celebrities dressing for themselves; clothes that enhanced them but were not costumes.' Anna Wintour later put it another way: 'Armani gave movie stars a modern way to look.'

And the same could be said of Richard Gere's look in *American Gigolo*. Although ostensibly a dark tale about the shallow life of an elite male prostitute, the movie was a paean to sartorial elegance. The very first scene sees Gere's character Julian visit his tailor. 'To me, the clothes and character were the same,' said Schrader. 'I mean, this is a guy who does a line of coke to get dressed!' The hero's preference for Armani and indeed the importance of the character's wardrobe in the film conveyed a sophistication that, if not quite redeemed, certainly made the character more alluring. Off set, Gere was not used to such exquisite subtleties of grooming. 'At that point, I didn't even know how to wear a suit or tie a tie,' he remembers. 'But I learned.' Like many others, Gere's first taste of Armani would flourish into a full-blown addiction. 'I don't know any other designers.'

American Gigolo was a critical and commercial hit, but in the fashion world it was a blockbuster. As a new decade began, its aspirational identity was clad in Armani. By the time Don Johnson

swaggered onto American TV screens as the suit and t-shirt-rocking protagonist of *Miami Vice* in 1984, the deconstructed Armani jacket was cemented as the number one status symbol for the dashing, debonair alpha male. As his profile grew, Armani began a campaign to reach beyond movies to the stars themselves. If the marriage of Hollywood and fashion now seems an easy one, with every gala evening's red-carpet prelude acting as a veritable runway show, its genesis was anything but. While both designers and celebrities would love you to think it a happy coincidence – the meeting of a stylish eye with an irresistible design – the truth is that a team of elves has been working behind the curtain to make it happen.

overleaf Armani dressed Helen Mirren first for the film The Comfort of Strangers, *imagining her character as elegant and sensual in long, silken robes. He was still dressing her (in white satin and tulle) in 2002 when she was nominated for an Academy Award for* Gosford Park. *Here she wears a sharp, pleated white satin cardigan-style jacket. Photograph by David Bailey.*

In 1988 Gabriella Forte, who had become Armani's head of international sales in the wake of Sergio Galeotti's death, hired Wanda McDaniel for a job described as 'Hollywood Liaison'. McDaniel was a writer and the wife of the producer Albert Ruddy. Her coup was reaching out not just to the stars, but also to their agents, managers and lawyers, helping to build a cult of style around Armani and spreading his influence even further.

What started as Armani's foresightedness has become a million-dollar money-spinner, with the power held by A-list celebrities and the designers themselves, but with influence being brokered by middlemen, agents, managers, film-studio executives and, of course, stylists. The end in view, apart from the global media impact, is that the desirability of the brand will accrue not only to sales in fashion but also spread to cosmetics and scent for to those eager to buy into an A-list lifestyle.

By the 1994 Oscars ceremony Armani's score on the 'who's wearing who' list was impressive: Glenn Close, Whoopi Goldberg, Emma Thompson, plus most of the black tuxes in the room. 'Rumour has it that Armani SPA has an office in LA devoted to lobbying the "right" sort of potential clients into the designer's sheath dresses and dinner suits,' wrote British *Vogue* in 1995.

'ARMANI GAVE MOVIE STARS A MODERN WAY TO LOOK.'

ANNA WINTOUR, VOGUE

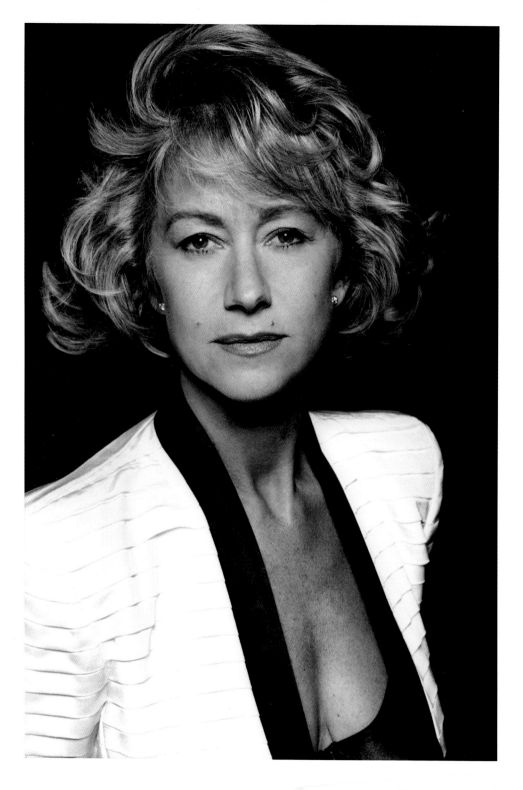

'Local papers are scanned for who's in town and then – with all the subtlety of those famously understated Armani designs – the people are seduced into his clothes.' By the mid-nineties Armani had also designed outfits for a further 21 films, such as *The Untouchables*, *Pulp Fiction* (including Uma Thurman's iconic outfit), *Batman* and *Goodfellas*. By the end of the decade that number had risen to over a hundred. He also reunited with Schrader for *The Comfort of Strangers*, featuring Christopher Walken and Helen Mirren as a devilish husband and wife, permanently resplendent in elegant white suit and silken robes respectively. He dressed Mirren for that and was still dressing her in a white satin and tulle confection in 2002 when she was nominated as Best Supporting Actress for *Gosford Park*. 'The last time I tried to pull him into a film,' noted Schrader in 2012, 'his representative told me: "We don't do films anymore. It's too much work. We prefer to just do the red carpet!"'

Actress Glenn Close constantly chooses Armani for the red carpet, saying, 'It's classic and beautiful and you can still be yourself. You don't have to worry about all the frou frou and stuff.' Here she wears a white satin suit with cardigan-style jacket and fluted hem skirt.

There are certainly exceptions though, especially when it comes to old friends and collaborators. Jodie Foster, who's been wearing Armani on the red carpet since her Academy Award win for *The Silence of the Lambs* in 1992, had him specially design a range of power suits for her role in 2013's *Elysium* with the film's costume designer April Ferry. 'She remains one of my favourite actresses,' he said of Foster. 'I admire her work, her talent, her life.' Tom Cruise, another aficionado whose entire family was outfitted by Armani (as was the bride's) for his wedding to Katie Holmes, wears made-to-measure suits in the *Mission Impossible* series, embroidered with a label reading 'Giorgio Armani for Ethan Hunt' (the name of his character). Likewise, when he dressed Christian Bale's alter ego in Christopher Nolan's hugely successful *Dark Knight Trilogy*, Armani even ran a viral campaign

'In an Armani outfit I don't lose my identity.'

GLENN CLOSE

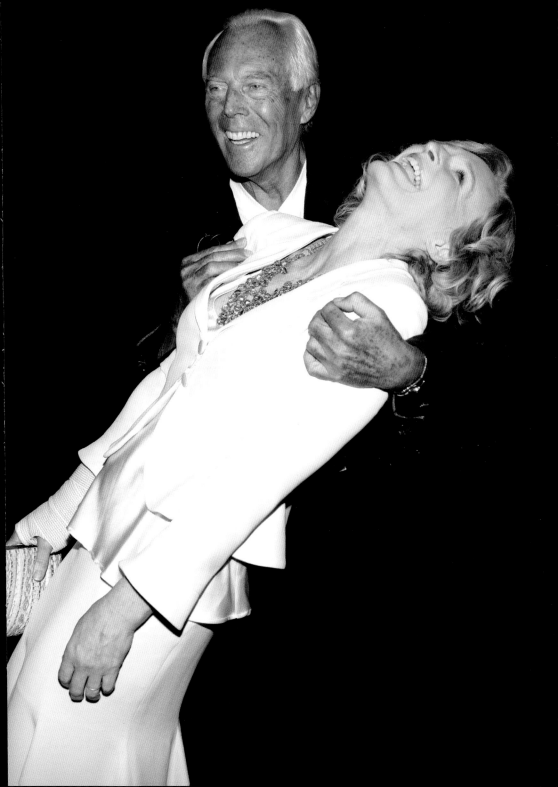

promoting his efforts as 'Hand Made to Measure. Giorgio Armani for Bruce Wayne.' But it is perhaps his collaboration with his long-time friend Martin Scorsese that defines his endurance and popularity in the movie business.

'I've been privileged to be a friend of his since 1983, and so we've always tried to work together on pictures,' says Scorsese. The attendance in Venice at the premiere of *Made in Milan* demonstrated just how much Armani had ingratiated himself in Hollywood. 'Probably no other designer in the world', wrote Lisa Armstrong in *Vogue*, 'could have enticed Michelle Pfeiffer, Meg Ryan, Dennis Quaid, Angelica Huston, Gore Vidal, Tom Stoppard, Kathleen Tynan, Lauren Hutton and Gary Oldman among others to devote an entire weekend away from home, burnishing HIS image.' More recently, when it came to dressing Scorsese's characters (especially fellow Armani fan Leonardo DiCaprio) for the eighties-set black comedy *The Wolf of Wall Street*, there could only be one choice. 'He understands the characters, and therefore his dressing of the character really is that character,' commented Scorsese. 'I knew he would have the perfect touch. To know when enough is not enough, or too much is too much. I've always loved the way he makes people appear.'

Armani's own sketch of a pinstripe suit for Leonardo DiCaprio as Jordan Belfort in director and friend Martin Scorsese's The Wolf of Wall Street *(2013), which captures both the style of the 1980s and the character of the fraudulent stockbroker DiCaprio portrays.*

It's important to remember how revolutionary Armani was: initially, fashion designers – who prefer to see their clothes on a supermodel elite of willowy giants – were reluctant to make or lend clothes for 'real' people with less-than-perfect bodies. Many film and theatre stars are surprisingly small and not necessarily suitably emaciated. Before there were millions of dollars to be made, it was not a popular marketing ploy, but by the beginning of the nineties many other designers were looking at Hollywood and the red carpet as more than just a photo opportunity. Versace was quick to see the value of dressing the stars, as were Gucci, Valentino, Calvin Klein, Jean Paul Gaultier and Carolina Herrera. But Armani was still ahead of the game. 'He saved the Oscars from degenerating into a tacky swamp by becoming the go-to designer for room-stopping yet tasteful dresses,' says Lisa Armstrong.

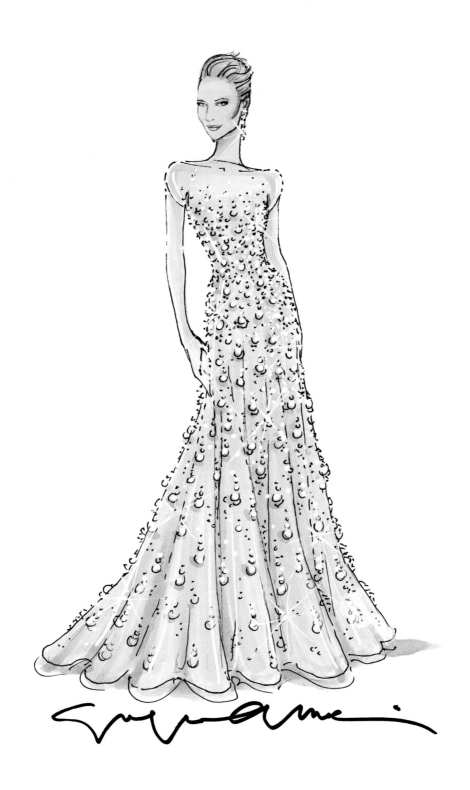

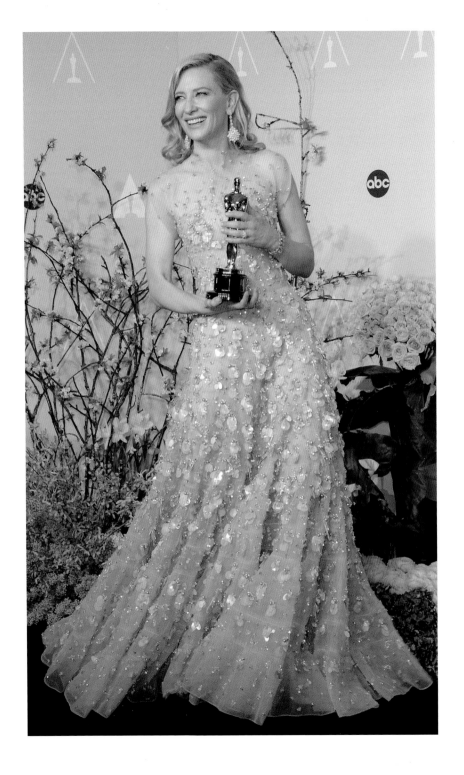

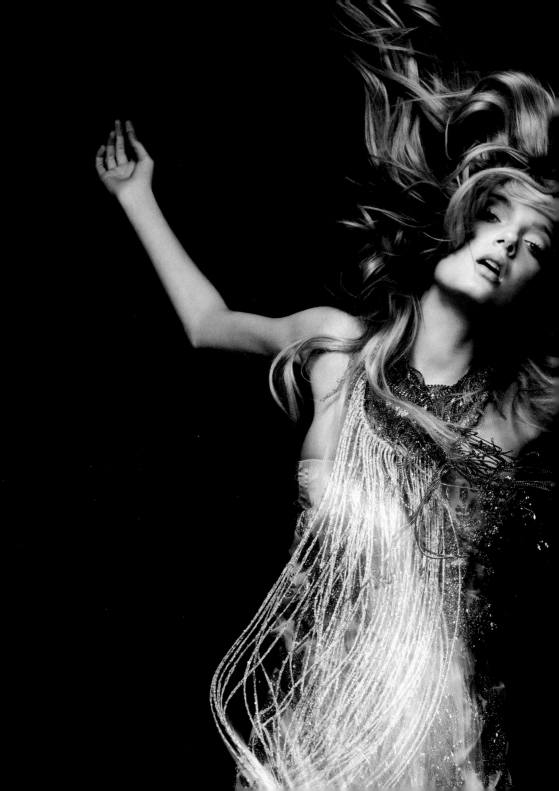

Armani's tulle dress and beaded fringe neckline – photographed by Nick Knight on Lily Donaldson – 'capture the flapper's freedom', according to Vogue.

previous pages Armani's sketch of Cate Blanchett's Oscar dress (left) and the the reality of that vision (right) as Cate Blanchett picks up the 2014 Oscar for Best Actress for her performance in Woody Allen's Blue Jasmine. The dress, reputed to have cost $100,000, was a full-length, semi-transparent creation embroidered with gold beads, sequins and Swarovski crystals, graduating from a simple neckline to a full-skirted hemline.

'That's quite a feat. The fact that Cate Blanchett practically stole the Oscars show in 2014 in a beautiful shimmering Armani column dress more than 20 years after Michelle Pfeiffer pulled off the same trick (that time in an Armani tux) says a lot about consistency.'

Having changed the goalposts of red carpet dressing, Armani certainly took the whole experience up a notch after the launch of his Privé show at the Couture Collections in Paris in 2005. 'To pull off this made-to-measure collection, Armani has hired 22 seamstresses to work in his Milan headquarters. It's a serious financial investment, but also a logical, pragmatic move: ultraspecial dresses like these are aimed directly at the Hollywood market he's had a handle on for years,' wrote Sarah Mower in American *Vogue*. Mower called it a 'daring gesture of self confidence' in his 70th year. To date, Armani has 50 *petites mains* (seamstresses) to work on these couture creations and estimates that to make a dress such as the one that dazzled the assembly in 2009, worn and won in by Anne Hathaway, would have taken two to three thousand hours of work.

Armani for evening mines a rich seam of opulence, transparency and glimmer. 'Slow burning glamour', says Vogue. Armani manages to create a traditional herringbone pattern out of sequins or a trompe l'oeil black tie. His default position is whispers of tulle, lace and chiffon. Photographs by Michel Arnaud and Sean Cunningham.

Never glitzy or vulgar, Armani's dresses remain true to his code – often in a palette that is mainly black or neutral – a colour which the Americans quaintly call 'blush' but which is more in the 'flesh' 'taupe' 'nude' spectrum. They are often sprinkled with thousands of crystals, sequins, bugle beads and fringing, some embroidered onto the most delicate and transparent of voiles, tulles, nets or muslins and often with a nod to his favourite Art Deco period in the form of slinky fishtail-hemmed slip dresses or beaded flapper skull-caps. 'Couture gives me the opportunity to fully liberate the imagination and create exquisite clothes, those of dreams,' he says.

Appropriately, in 2003 Armani became the inaugural recipient of the Rodeo Drive Walk of Style, a fashion award conceived as a sister honour to Hollywood Boulevard's Walk of Fame. Later, he became involved in a different aspect of film design when he collaborated with director Robert Luketic to create a set for the 2013 thriller *Paranoia*.

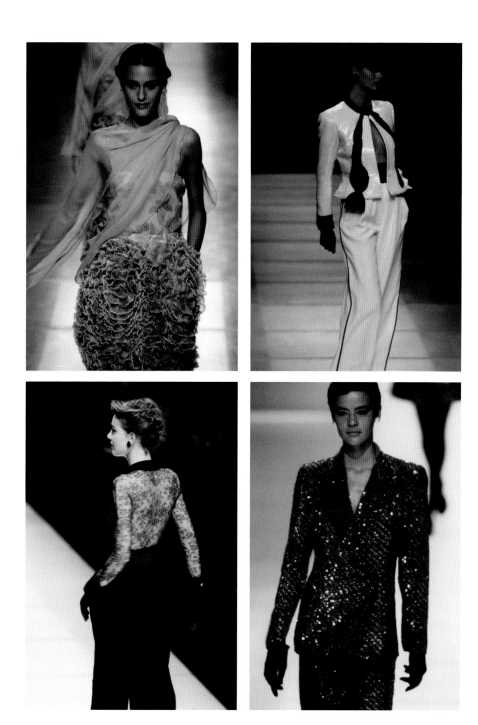

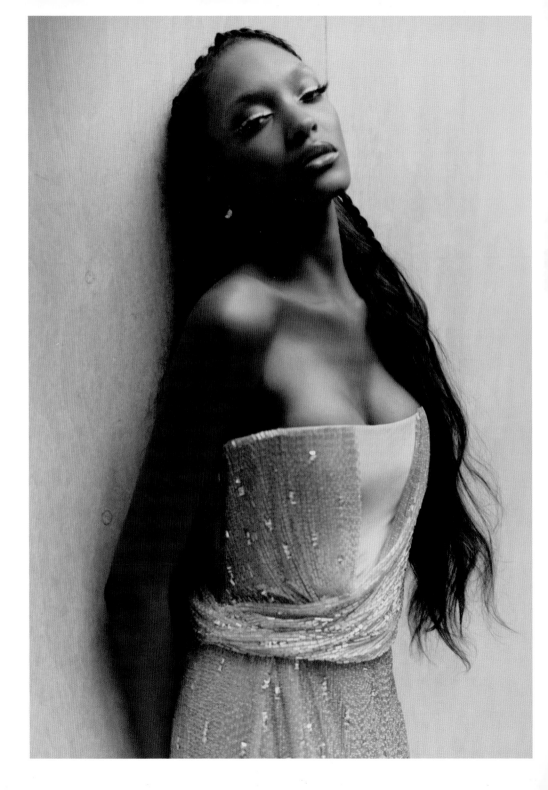

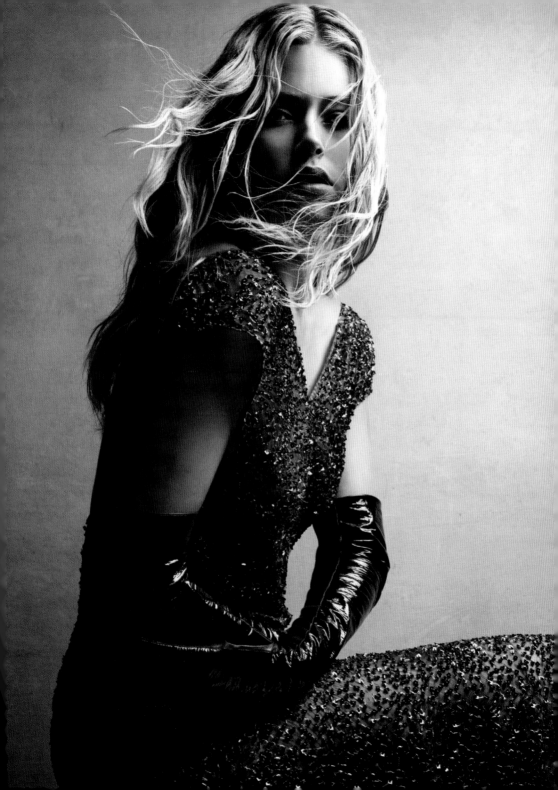

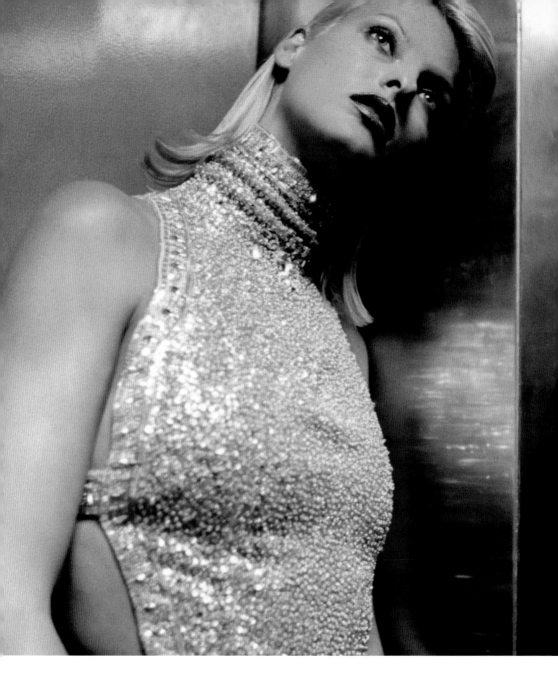

'I'VE ALWAYS ADORED PRECIOUS MATERIALS.'

GIORGIO ARMANI

Many women have spoken of wearing Armani being like a sort of protection. Here Linda Evangelista sports evening armour in the form of a shield of close-cut silver and crystal beads, which form a backless halter-top with a high polo neck. Photograph by Glen Luchford.

previous pages Jourdan Dunn wears a bugle-beaded shell-pink dress (left) from Armani Privé, Armani's Couture line. Each piece is custom-made in the atelier. Photograph by Tyrone Lebon. A liberal scattering of graphite beads and crystals over a deceptively simple sheath gown worn by Doutzen Kroes (right) is Armani's sleight of hand in effortless glamour. Photograph by Patrick Demarchelier.

Encouraged by the success of the Armani Casa range (a furniture and home accents collection launched in 2000), Armani designed a sophisticated modern apartment for Chris Hemsworth's lead character. While on the surface it marked a big departure for Armani's work on film, he might perhaps never have been closer to that shy little boy designing plays with his brother.

Before being caught up with Hollywood, Armani had always dressed stars, starting at home with a bevy of iconic Italians. In 1994 on a shoot for *Tatler*, he sent his number one press officer armed with two racks of clothes just to make sure there was something right for his friend Sophia Loren to wear. Claudia Cardinale, the star whom David Niven called 'Italy's happiest invention after spaghetti', has consistently been a front-row ambassador at all his catwalk shows, as has Isabella Rossellini, whom he has known since she was a child. Armani has always been acutely aware of the role these kind of celebrity ambassadors play and understood early on that the cross-fertilisation between film, music or art could also bring commercial profit.

The commercial rewards of having beautiful people seen everywhere in your clothes is a PR coup that Armani utilised long before street style became a brand building exercise. Ever since the eighties he's been very clever in his choice of representatives: people paid to appear publicly looking great in his clothes. One of the shrewdest of these was his appointment of Lee Radziwill, Jackie Kennedy's sister and a key socialite and fashion figure in the US, and he went one better when he enlisted a British royal as his brand ambassador. 'Welcome to royalty 2000,' wrote Alexandra Shulman in British *Vogue* when Lady Helen Taylor, daughter of the Duke and Duchess of Kent, was announced as being paid to wear Armani. 'Who better to fly the Armani flag', wrote Shulman, 'than this pretty, cultured, modern royal who looks as good in a plain navy trouser suit as she does in a skimpy sequined tabard.'

Liz Hurley wears a silk blouse embroidered with silver filigree detail, worn over tuxedo wool trousers. There's often a hint of the 1920s and 1930s in Armani design – a favourite period of his. It's most apparent on delicate materials for evening in his love of intricate beading and fringing. Photograph by Mario Testino.

overleaf *HRH The Duchess of Kent 'has adopted a style which is founded on comfort, simplicity and grooming,' writes Alexandra Shulman in Vogue. Not surprising, then, that she favours Armani. Photographed by Patrick Demarchelier (left) she wears a beige lace jacket and trousers with a white silk top. Lady Helen Taylor photographed by Michel Comte in a simple Armani sleeveless black dress (right).*

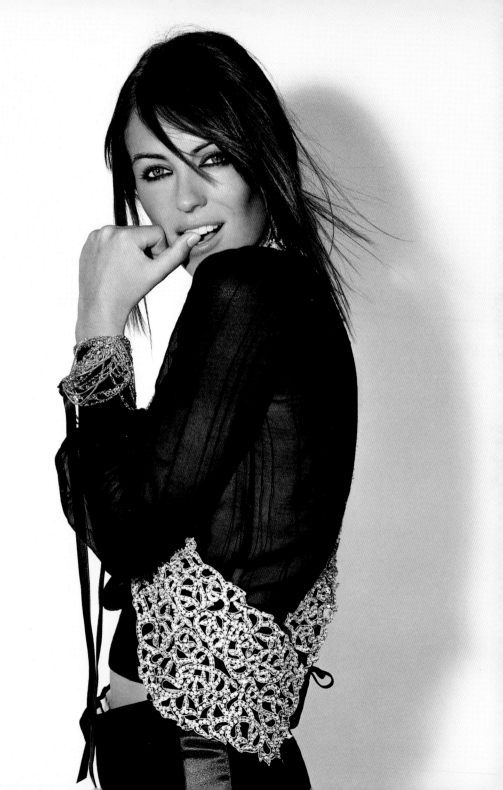

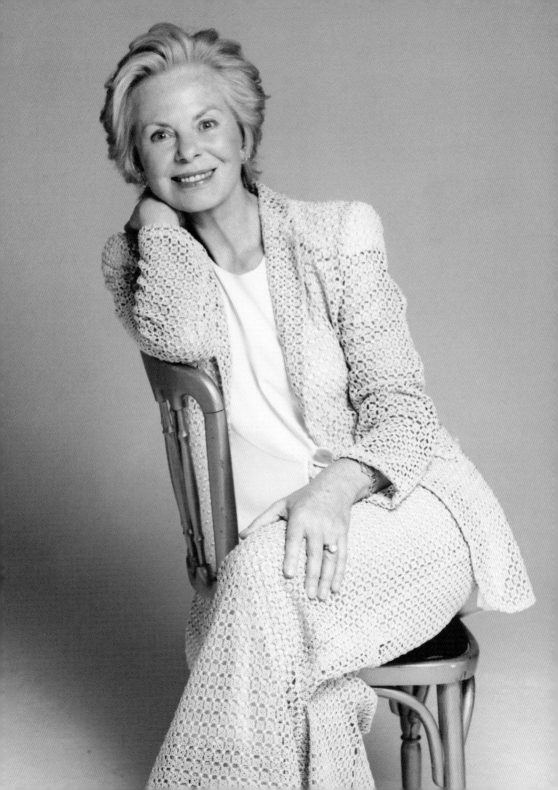

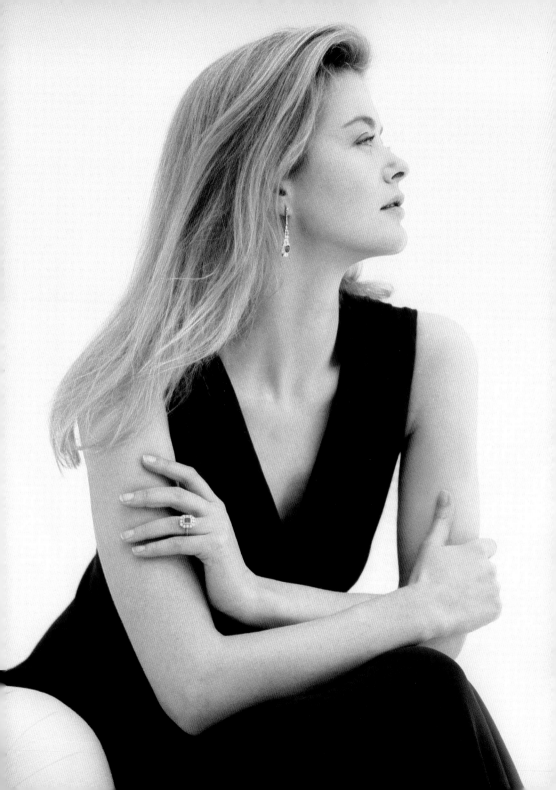

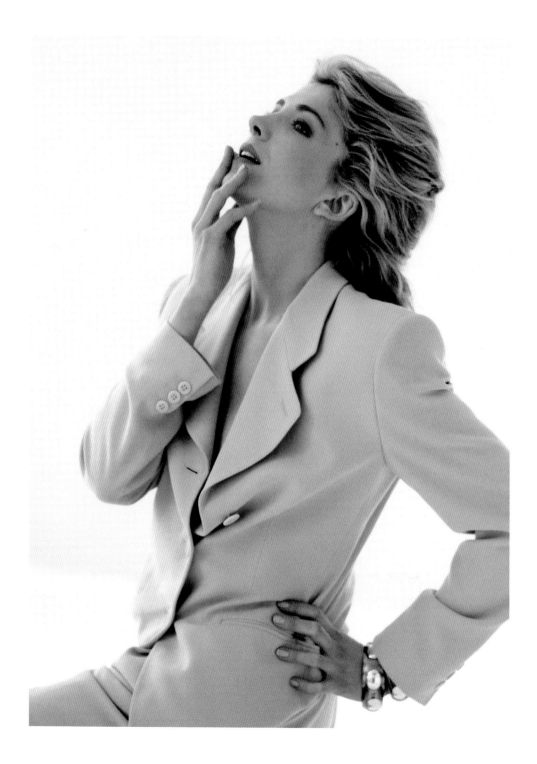

Lady Helen's connection with Armani had begun some years earlier. 'Whenever I had to go to some function they would try and help me out,' said Lady Helen. 'I suppose I was 23 or 24 at the time and didn't really have much sense of style. He really helped to define that. I realized what suited me best was a simple minimal approach to dressing. Mr. Armani was incredibly generous to me.'

Generous is a word frequently offered. The label is still hugely popular on the red carpet, with everyone from Angelina Jolie, Adele, Rihanna, Anne Hathaway and Penelope Cruz wearing it, and ask any Armani-clad celebrity about their relationship and they'll invariably say how generous and supportive he's been.

The actress Natasha Richardson photographed by Arthur Elgort in a cream wool single-breasted blazer and matching tapered trousers. A perfect example of 'less is more', a maxim that could so easily be Armani's mantra.

overleaf Singer Rihanna wears a black silk cady and floral print shantung cocktail dress with a velvet band at the waist, from the 2011 autumn/winter Armani Privé collection. Photograph by Alasdair McLellan.

'When I first actually met him, he was fitting me for a dress backstage after a Privé show,' recalls Cate Blanchett. 'He got down on the floor and started measuring my hemline. He didn't have someone else do it, he did it himself. He was there – the great man – literally at my feet. It was a way of saying, in this moment you are the most important person. It was a profoundly generous thing for him to do.' Blanchett's ambassadorship is the culmination of a long relationship with Armani; not only has she benefited from stunning outfits for the red carpet and beyond, but it has also led to his providing funding for and becoming patron of Australia's eminent Sydney Theatre Company, of which she was until recently co-artistic director.

Whether he's on his hands and knees to ensure the perfection of Cate Blanchett's hem (he's 80) or carefully tailoring every suit for *The Wolf of Wall Street*, Armani clearly cares about the image he presents to the world, and the people who facilitate it. To them, he's just as much a star as they are, if not bigger, and few brands permeate the cultural landscape quite like Giorgio Armani.

'With all the subtlety of those famously understated Armani designs … people are seduced into his clothes.'

VOGUE

'AN END OF THAT GLITZY, OVER-THE-TOP WAY OF DRESSING.'

ANNA WINTOUR, VOGUE

VOGUE

®

NOV
£4.10

MID-SEASON SPECIAL
45 favourite pieces

TILDA SWINTON
THE GREAT PERFORMER

Night fever
70s sequin chic and 40s goddess glamour

MEET THE NEW GLOBAL STYLE HUNTERS

Rare passion
How we fell in love with meat again

LUSCIOUS LASHES
Winter's ultimate accessory

RIHANNA ROCKS
in fashion's new glamour

'I WANTED TO TAKE CARE OF THE
HUMAN BODY. THIS INCREDIBLE
MACHINE THAT TO THIS DAY
REMAINS A MYSTERY.'

GIORGIO ARMANI

IMPERO ARMANI:
THE ARMANI EMPIRE

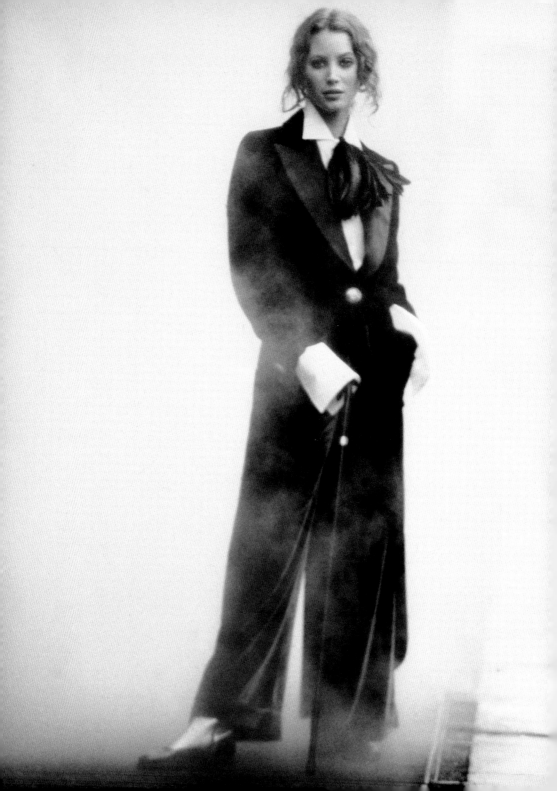

Armani may not have been the first designer to dream up the concept of 'brand', but he was certainly blessed with that instinctive, exuberant Italian way of selling-entertaining-partying that promotes a stampede to the showrooms for more than just haute couture. Coco Chanel launched her first perfume (Chanel N°5) as a gift (with purchase) to loyal customers, and Pierre Cardin in the sixties exploited the idea of the designer label by putting his name on everything from ties to frying pans, but this proliferation was to dilute his name on products that often had no relevance to the DNA of his original designs. Other designers established the germs of 'diffusion' but Armani, ever focused, went further. Still holding on to 100% ownership of his brand and in complete control of what went out under his name, he launched first Collezioni and then Emporio Armani – reputedly his favourite of all the spin-off lines – with the philosophy of making his designs more available to everyone.

'A second line is a key career move,' wrote Sarah Mower in British Vogue. 'Armani sets the example here.' Christy Turlington shows how to get the Armani look for less in head-to-toe Emporio silk-lined, navy velvet tailcoat coat with satin lapels. Photograph by Arthur Elgort.

overleaf Armani pioneers the layered look and the concept of the humble t-shirt shape (left) in an exotic fabric in 1986, years before both ideas become mainstream; nowadays the mix of high fashion and high street is the norm. From early on, Armani wanted his design concept to be more accessible. Photograph by Michel Arnaud. Linda Evangelista wears unusually decorative earrings, brooches and necklaces (right) as well as a midnight blue georgette dress, all by Armani. Photograph by Patrick Demarchelier.

Indeed, Emporio was launched in 1981 – a mere four years after launching his signature brand – without knowing whether it would cannibalise existing sales and against the advice of his marketing team. But the idea that a consumer with less purchasing power could buy into the world of a top designer by owning something with an identifiable signature was ultimately to be rolled out with staggering financial success. Diffusion brands – a fashion house's secondary line of merchandise that retails at lower prices – have since become the bread-and-butter income of many designers. They are not only an affordable way to sell a designer's 'look', they also allow shops and retailers without access to the more exclusive artistic line a way of offering the label to a wider clientele, at concession outlets and high-street stores.

Armani's emporium needed an icon and the Emporio 'Eagle' logo came out of a design that Armani had devised for use on t-shirts. 'We were looking for a symbol – something that would fly high,' said Armani.

'It was a sketch that grew out of a couple of sketches I did on my note pad between phone calls.' Although Armani Junior and Armani Jeans were inaugurated around the same time, it was Emporio Armani that really 'flew'. Within two years there were nineteen Emporio shops around Italy, with the Emporio Bomber Jacket becoming a 'must have' hit with young men the world over. In 1982 he launched Emporio Underwear, Swimwear and Accessories. By now almost anything could be given the Armani signature but, unlike Cardin, Armani kept his branding under strict control.

In 1986 *Vogue* wrote: 'Designer pyjamas are the new short order and one of the more irresistible collections is Giorgio Armani's.' Armani Dolci, a range of square praline chocolates, teas and biscuits, not to mention Armani Fiori (flowers) and Armani cafés and/or restaurants inside the Emporio branches offered Armani fans another sort of irresistibility. In the late eighties, together with opening Armani Japan, came a sock line, eyeglasses, a gift collection and, in 1991, A/X Armani exchange, an American men's and women's line offering the lowest prices of all and aimed not only at the US but also at the young and cool.

'Under assault of recession and the post-eighties, anti-designer backlash, the smart move for any designer with an ounce of common sense has been to diversify quietly into cheaper ranges,' wrote Sarah Mower in British *Vogue*. 'A second line is a key career move,' she continues. 'Armani sets the example here, aiming to dress the entire roster of Hollywood stars at the Oscar ceremonies in his collection, a generation of middle management in Mani, the young aspirationals in Emporio Armani and anyone who owns a pair of jeans in A/X, a new basics line launched this year.'

'Big is beautiful when it comes to sunglasses,' said Vogue of this tinted pair. Armani first introduced a line of eyeglasses when he opened in Japan in 1988. In partnership with Luxottica Armani has produced prescription eyewear as well as more sunglass designs. Photograph by Robin Derrick.

overleaf *Armani expanded his diffusion line with Emporio Underwear, Swimwear, and Accessories. Here (left) is a scallop-edged bra and matching high-cut briefs in cotton jersey and (right) a palest peach and blue swirl print chiffon sarong and cotton and lycra cherub print swimsuit, at Emporio Armani. Photographs by Neil Kirk.*

'The difference between style
and fashion is quality.'

GIORGIO ARMANI

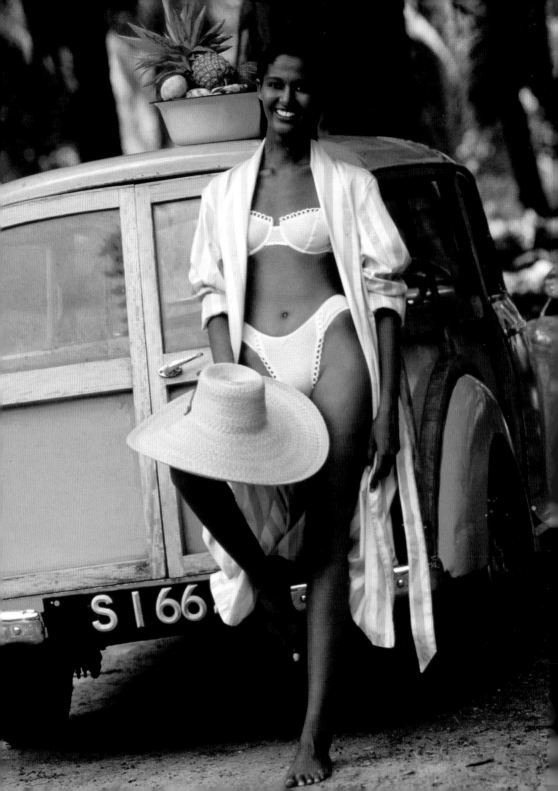

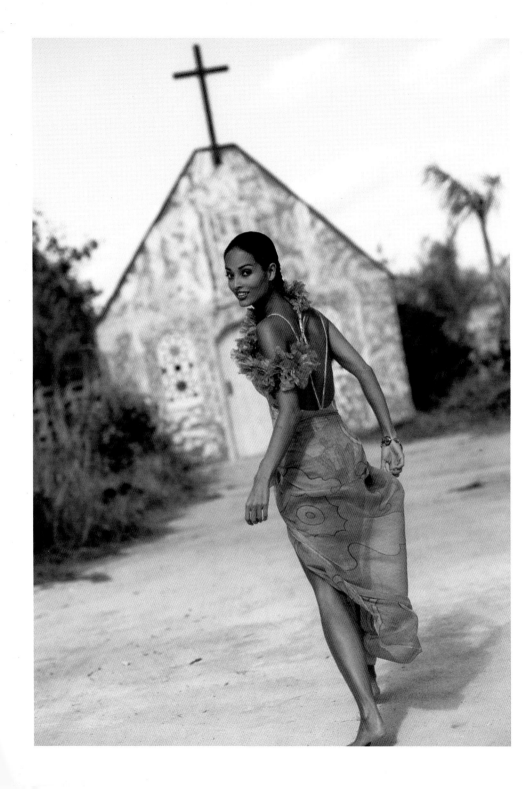

'CLOTHES SHOULD TRANSMIT SENSUALITY, NOT SEXUALITY.'

GIORGIO ARMANI

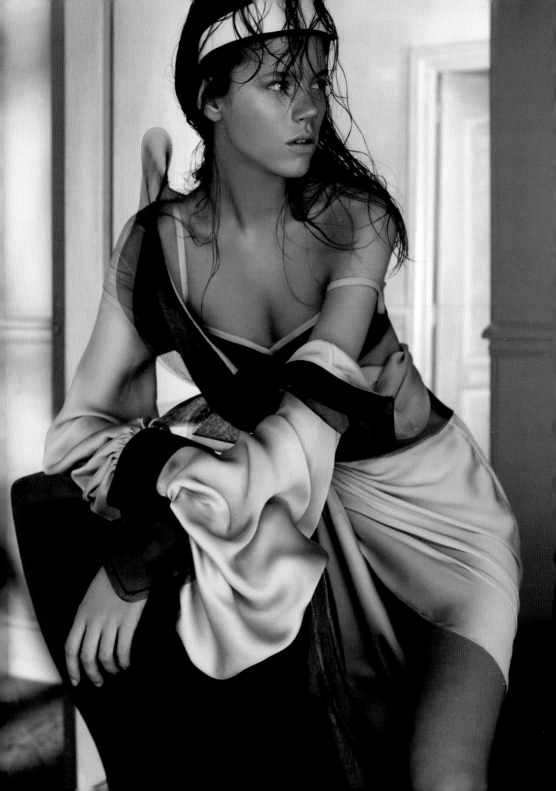

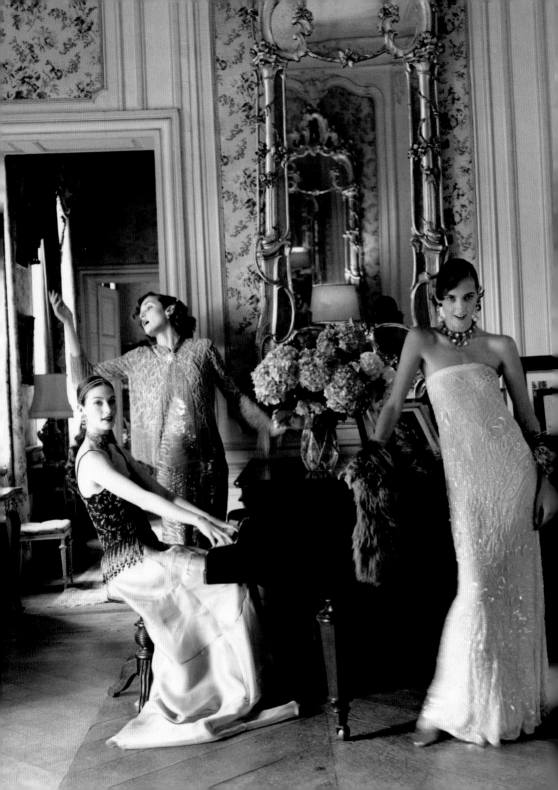

There were even more lines to come. In 1995 Armani introduced skiwear and ski casualwear. EA7, a later diversification in 2004, was a foray into the ever-burgeoning popularity of extreme sport and fitness and came about partly because of his enthusiasm for football.

While he had been refining daywear since the beginning of his brand in the seventies, he waited 30 years to launch Giorgio Armani Privé, a tour de force of sparkling and shimmering couture gowns which debuted in Paris in 2005, the 30th anniversary of his fashion house. 'Evening gowns in Ottoman silk, tulle, lace and satin organza with elaborate beadwork and enamel appliqué,' wrote *Vogue's* Sarah Harris. Armani told her, 'I have always included a small number of "special" dresses in the prêt-à-porter collections, so this presentation seems to be a natural progression, to cater to a certain type of client who demands an item of unique quality, produced to the standard of haute couture, but with the accessibility, ease and modernity of my fashion.'

He didn't stop there. A partnership with Samsung in 2007 has resulted in a mobile phone and a flat-screen television. A new partnership with Luxottica in 2012 has produced more designer sunglasses and prescription eyewear. The same year, stores just for Armani Junior (children's wear) opened in Rome and Florence; multi-brand stores have opened in Vienna and Berlin, second boutiques in New York and Paris, somewhere around three hundred stand-alone stores in China since his inaugural branch on the Shanghai's Bund in 2004, and the first Armani in Kazakhstan in 2014.

These examples of what Armani calls his 'special dresses', photographed by Arthur Elgort in 1998, were forerunners of his couture designs for Armani Privé. The gowns hark back to the glamour of a bygone era, with an abundance of glittering crystals and jet.

previous page *Freja Beha Erichsen wears an ice blue Charmeuse cocktail dress with black crinoline detailing from the 2006 spring Armani Privé collection. 'When I design clothes, I don't want to load a woman down with ribbons and brooches,' he says. More often his designs follow his signature style with a preference for neutral colourings, slightly thirties lines and lack of ornamentation. Photograph by Javier Vallhonrat.*

'The go-to designer for room-stopping yet tasteful dresses.'

LISA ARMSTRONG

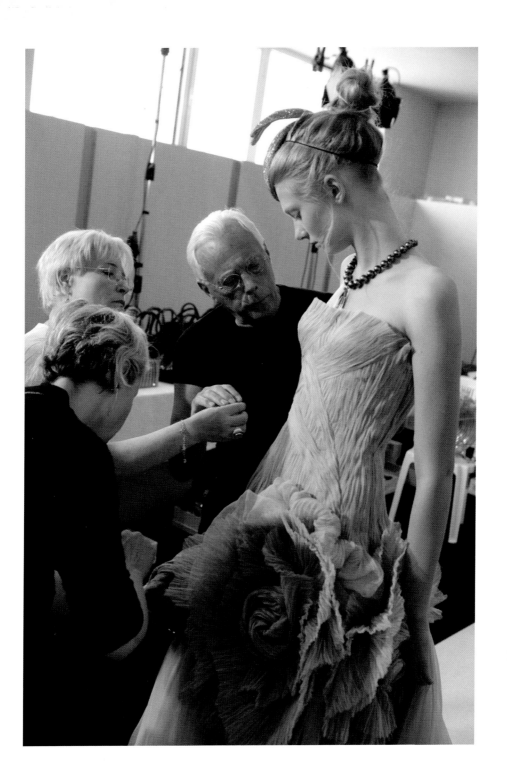

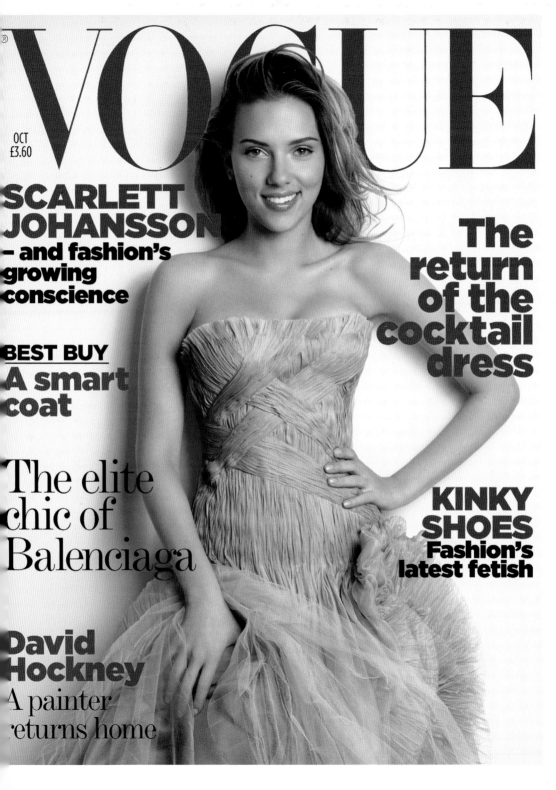

VOGUE

OCT
£3.60

SCARLETT JOHANSSON
– and fashion's growing conscience

BEST BUY
A smart coat

The elite chic of Balenciaga

David Hockney
A painter returns home

The return of the cocktail dress

KINKY SHOES
Fashion's latest fetish

'GREY IS ARMANI'S LANGUAGE.'

SARAH MOWER, VOGUE

Armani's colour palette is subtly influenced by the tones of sand, sea and the shimmering light of summer. Arthur Elgort photographs Claudia Schiffer in a beaded shift dress with shoestring straps and a draped sarong skirt – evening glamour combined with ease and modernity.

previous pages At the age of 71, 30 years after the the establishment of his brand, the designer launched Giorgio Armani Privé, his 'molto elegante' couture line. Here he fits a model (left, photograph by Thibaut de Saint Chamas) with a strapless silk-organdie dress with pleated and draped bodice creation from the Privé collection, later worn by Scarlett Johansson on the cover of Vogue (right, photograph by Patrick Demarchelier).

'AN ARMANI
DRESS DOESN'T
GIVE YOU DOUBT
OR UNCERTAINTY.
IT'S AN ARMANI
AND THAT'S ALL
YOU NEED.'

SOPHIA LOREN

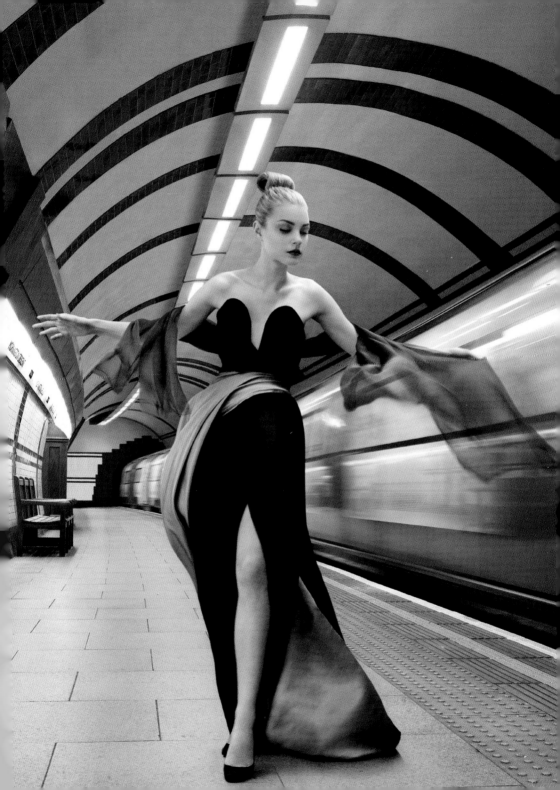

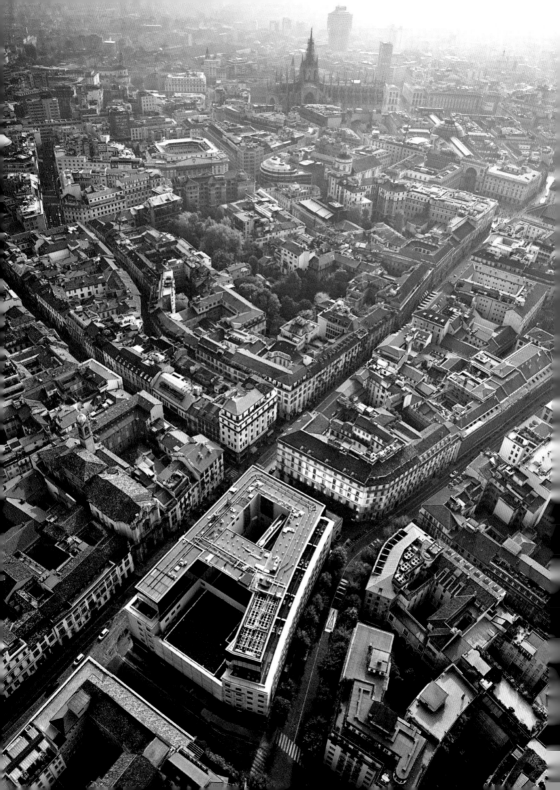

In his home town, Milan, a whole block of the Via Manzoni boasts a mini empire which from the air spells out a huge letter 'A' – a serendipitous inheritance from its previous owner. This influential stretch of real estate right in the heart of the city comprises two restaurants, including Armani Nobu, a night club, a café, a bookshop, a vast store offering all of the Armani lines and last but not least the Armani hotel. Here, the austere entrance and beige marble lobby lead to the thirties-inspired Bamboo Bar, buzzing with designer-clad, Italian A-list couples sipping negronis.

More than $8-billion-worth of Armani products was sold around the world in 2013 and the private Armani Group, Armani S.p.A, continues to post huge growth numbers every year despite Europe's economic struggles. The staggering success of this business of which Armani is still the 100% owner boosts his net worth, according to Forbes, into the billions. He is numbered on Forbes list of the world's most powerful brands and their list of the world's wealthiest billionaires. The Armani Group has more than 6,700 employees and 12 production facilities. Armani's distribution network includes 2,473 stores, comprised of 164 Giorgio Armani stores, 271 Emporio Armani stores, 469 Armani Collezioni stores, 270 A/X Armani Exchange stores, 722 AJ Armani Jeans stores, 167 Armani Junior stores and 59 Armani/Casa stores in more than 60 countries across the globe.

For a brand as big as Armani, the pressure to have a globally blockbusting fragrance is enormous; a partnership with L'Oreal has resulted in new scents for both men and women every couple of years for the last three decades. 'The designer himself has spoken about the difficulty of creating a woman's scent with a broad, continent-spanning appeal,' writes Nicola Moulton in *Vogue* at the launch of 'Idole d'Armani' in 2009, a grown-up opulent floral created by perfumer Bruno Jovanovic. Different scents, constructed with a plethora of 'noses', have been created both before and since 'Idole'.

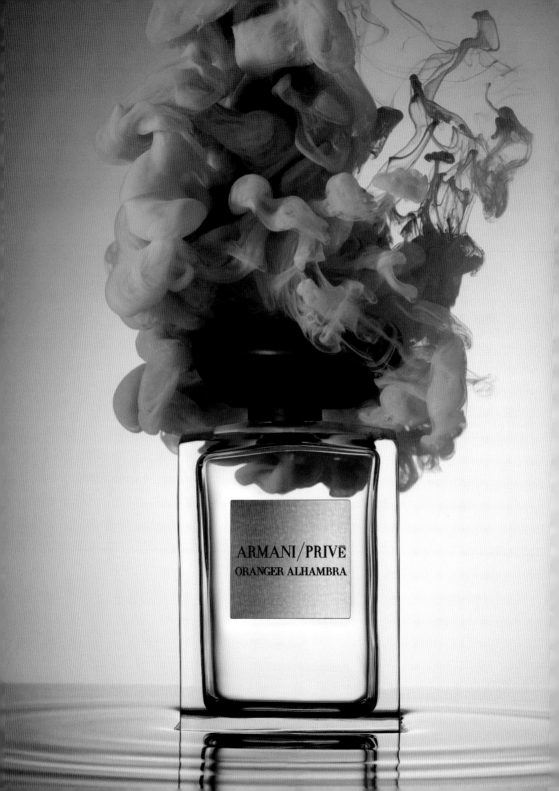

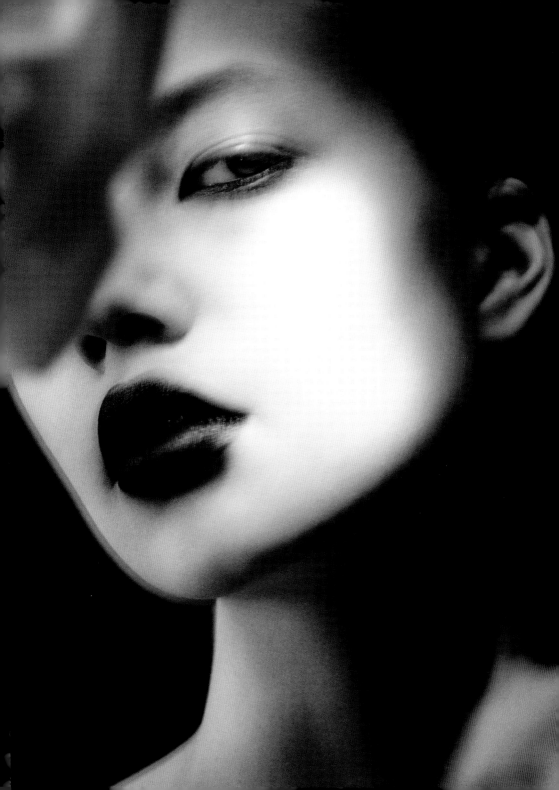

Interestingly, all Armani fragrances – mostly bottled in designs that are redolent of the thirties – are never as pared down and discreet as his clothes. 'Armani's theory is that perfume is an abstraction … a mystique,' writes John Oakes in *The Book of Perfumes*, reviewing Armani's first, eponymous offering in 1982 that is 'a positive volley of flowers, flagrantly, unashamedly Italianate in its vivacious outspokenness'. The man himself wears Bois D'Encens from the Armani Privé range, described as woody and mysterious by one critic and with rather sensuous notes of pepper, vetiver, cedar and incense. The commercial cologne that is Eau pour Homme, (citrus, spicy and woody) and then Aqua di Gio (inspired by the Sicilian isle of Pantelleria where he has a holiday home and probably the most successful of all his scents) came in the first two years of his L'Oreal association followed by Armani Code (orange blossom notes) and finally Armani Privé (also the name of his nightclub in Armani Nobu and of his couture collection), the last perfume to be called 'Giorgio', 'Armani' or some derivative of his name or nickname. As the fragrance industry turned to celebrities to help sell their newest aromas, Armani played along, with his clout and contacts landing Beyoncé as the face for Diamonds and latterly Cate Blanchett as the muse behind his latest creation, Sì.

previous pages Armani Privé Oranger Alhambra perfume (left), inspired, says Armani by 'childhood memories of freshness and the sunlight of the Mediterranean.' Photograph by Lacey. Make-up created by Linda Cantello, make-up artist for Giorgio Armani Beauty, using Armani cosmetics (right). Photograph by Benjamin Lennox

The launch of Armani cosmetics came in 2000, again in partnership with L'Oreal and with Linda Cantello – an internationally acclaimed make-up artist – to consult on formulation. The packaging has all the hallmarks of Armani style: sleek, discreet, matte-black cases with a hint of Art Deco about the design and a focus on texture, quality and detail, such as the piece of polished obsidian that acts as a scoop for his face cream, the luxurious powder brush made of real

'He's basically the best professor you could ever meet. You have a little bit of fear but also a huge admiration.'

LINDA CANTELLO

hair or the Chinese-lacquer red casing for Lip Maestro – a range of intensely pigmented matte lip colours. 'Such attention to detail – it's amazing,' says Michi Prendin, his Senior Manager, Global Editorials for the last thirteen years, 'and such passion. He is still the same today as he has always been. He's interested in the design of each bottle of perfume, of each container for the cosmetics, every detail, every colour.' Linda Cantello works closely with Armani at show time where he inspects each model and has even been known to add some blush himself, or move the hair around when creating the 'look' for the season. 'I find him fascinating and he's taught me a lot,' she says. 'He sees things in shapes and I see things in colour. He's very architectural and yet – at the same time – organic. I've met everybody there is to meet in the fashion world and he is the most charismatic. He is authoritarian – yes – but it's mostly his attention to detail. To my mind, he communicates on a different level. He almost sets you a challenge.'

overleaf On the catwalk, from autumn/winter 2014 Armani Privé (left), Armani not only played with cardinal red, black and white, there was a distinctively industrial edge to his use of modern materials – enamel studs, vinyl strips, cut-out ribbon spot in various sizes sprinkled over net and organza cut and shirred to look like fur. 'I see couture as a laboratory for experimentation,' says the designer. Photograph by Jason Lloyd-Evans. 'Coat dress neatly wrapped around the body makes a great alternative to the suit for day,' says Vogue of this red wool design for Emporio Armani (right), photographed by Neil Kirk.

Fashion designers are rumoured to be less interested or involved in the formulation of the scents or cosmetics that bear their names but Armani's touch is very evident in the design, detail and idea of almost every one of his diffusion lines. He may not actually do the formulations but the concepts are sketched out or take clear shape in his head. '*Non vivo fuori*,' he says. 'I don't live outside, the magic is in my brain.' Take his face cream, Crema Nera, incorporating the benefits of the indigenous, volcanic muds of Pantelleria. The initial notion for the super moisturizer came from a newly health-conscious phase of his life brought on, claims Nicola Moulton in *Vogue*, by seeing Gunther von Hagen's *Body Worlds* exhibition in New York.

But if a face cream evolved from a new health-giving regime, the purchase of an apartment in New York was a more prosaic starting point and laboratory for the eventual launch of his Armani Casa range. As he furnished the apartment, he applied all his usual rules of simplicity and deconstruction, thinking of it as a continuous whole rather than as a series of differently decorated zones.

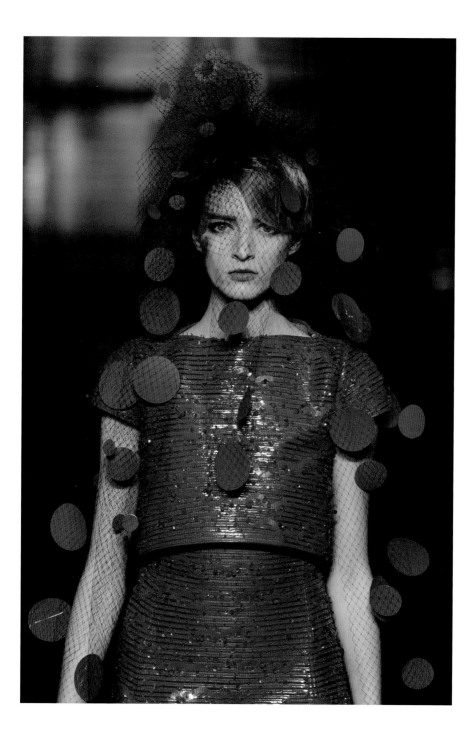

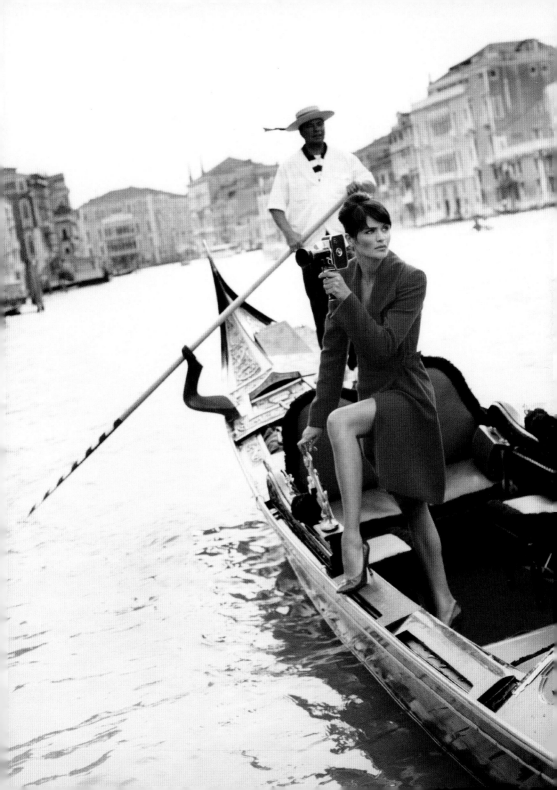

With dark floors throughout, parchment-coloured linen-covered walls and understated, flattering lighting, the result was an equilibrium of subtle contrasts. It was also a precursor of the now-fashionable 'high low' concept – mixing old with new, expensive with inexpensive; there were the linens he so loves but this time draped over sofas and stools, inexpensive rattan carpets in blonde tones for texture and practicality and subtle lighting to give a warm glow throughout. 'When I design clothes, I don't want to load a woman down with ribbons and brooches,' he said in an article in *Architectural Digest* by Holly Brubach. 'It's the same in the home. I don't want to fill the space.' The furniture, fabrics, linens and household accessories in Armani Casa are an extension of his signature style with neutral colourings, slightly thirties lines and a lack of ornamentation. 'I've removed superfluous details,' Armani says of his role in conceiving products for the home as well as in designing fashion. The effect has been described as monastic, but the continued relevance of his minimalist style is evident from the many Armani Casa outlets internationally – New York, Paris and Los Angeles, for instance – and from the ever-growing portfolio of Armani-decorated and designed hotels and residences.

Accessories, including sunglasses, socks and handbags, are all part of the Armani empire. Here with all his usual attention to detail, his love of the Art Deco period is evident in a bag design that could have come straight from the 1920s. But Armani is a futurist and although he hints at the past, the industrial edge to this design is essentially modern. Photograph by Peter Lindbergh.

'The key to my success is perseverance and vision,' explains the designer, when asked how he manages to leap from jeans to couture and come up with ever new ideas. '*Questo è mio vero genio* – that is my true genius,' he says with humour. 'I'm a bit of a chameleon. *È un dono*. It's a gift. I know what I want, everything needs to be in a certain way and only I know that. The clothes need to be a certain way, for a show the models need to walk in a certain way, and I need to see every single element. I would say that I'm a true workaholic but that is both a value and a defect. I bring the same consistent approach to every aesthetic canon to which I aspire – and I never stray. If you know exactly what you are aiming for, then it is not difficult to remain coherent.'

'HOWEVER FASHION FLOWS, POWERFUL DESIGNERS FOLLOW THEIR OWN CURRENTS. AND ARMANI'S INSTINCT IS FOR LIBERTY, EQUALITY, SOBRIETY.'

SUZY MENKES

THE KING'S REACH

For a figure whose work life is all encompassing, it's easy to imagine Armani as a man with little time for outside interests, only concerned with the next collection, the now. His reputation as a control freak, with an almost fanatical perfectionism (one journalist noted he spent twenty minutes practising his signature before a book signing) and his dictatorial presidency over every aspect of his work doesn't lend itself to the image of a man who lets loose or indulges in extra-curricular activities. Indeed when asked what he would do if he was invisible for 24 hours and could do anything or go anywhere, his answer was candid; 'I'd go to work and remain out of sight to see how it all works without me.' But the work–life compromise isn't as lopsided as it seems. He simply combines the two, bringing those things beyond fashion into his sphere of influence and under his precise control. It's his own observation that 'I don't have many friends' but what he really means is that he doesn't have many friends outside work. His family and close friends, lovers, cousins, nieces (from Galeotti, to Roberta and Silvana, the daughters of his late older brother Sergio, his nephew Andrea Camerana, Rosanna's son, and Panteleo (Leo) Dell'Orco, his right-hand menswear designer and friend for over twenty years) and a few faithful retainers are also part of this symbiotic relationship. His work may be his passion, but his passions are also his work.

Far from being immune to art, music or sport, he simply chooses to engage with them differently. Where some might take a break to enjoy a concert or a game of football, Armani immerses himself, designing the outfits, the kits or even the gallery. Few things typify this interdependency more than his first love – cinema – a conduit not just for his creative and commercial expansion, but also for emotional fulfilment. Cinematic themes and moods permeate his packaging, his designs and his advertising, and not one of his many lines from Privé to Emporio to Casa is untouched by this particular enthusiasm. Even his Frames of Life glasses range were used to launch a project in conjunction with Rai Cinema in 2014, where film students were challenged to create short auteur pieces using the product as a perception filter. This kind of venture is indicative of his desire to involve himself in his passions at ground level.

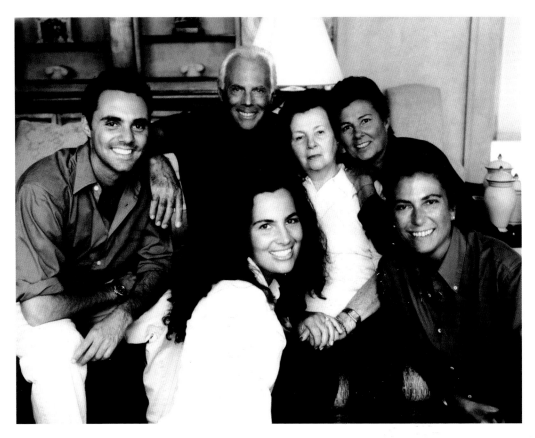

The Armani clan present and future
(clockwise from left): Andrea Camerana
(nephew), Giorgio Armani, Maria Armani
(mother), Rosanna Armani (sister) and
Silvana and Roberta Armani (nieces).
Armani's family and few close friends
and collaborators are also those he
spends his spare time with.

overleaf Kate Moss wears a bright red
tulle dress with Swarovski crystals and
sequins, suspended from the wispiest
of spaghetti straps (left), a dress that
could be considered an Armani classic –
timeless, elegant and urban. Photograph
by Nick Knight.
Giorgio Armani's ability to design
beautiful dresses like this full-length,
glittering, beaded gown (right) came
as a surprise in 2000 to some of the
visitors to the Armani retrospective at
the Guggenheim, who were astonished
by the spectacular evening wear.
Photograph by Liz Collins.

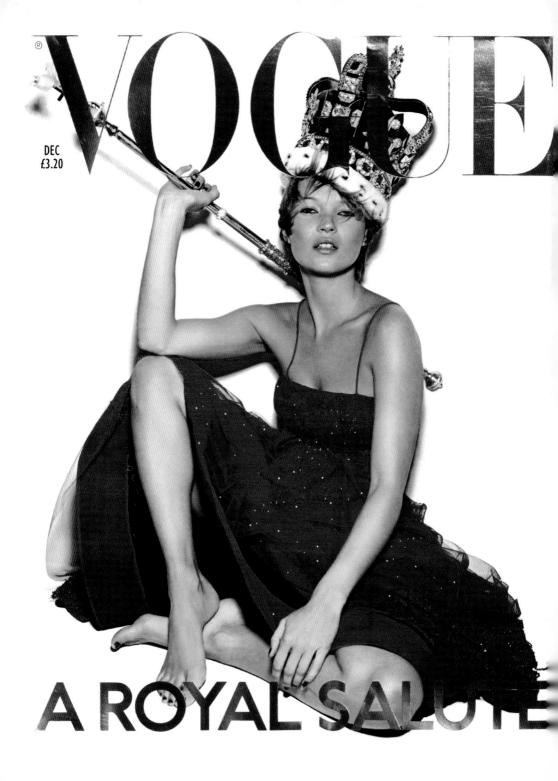

VOGUE

DEC
£3.20

A ROYAL SALUTE

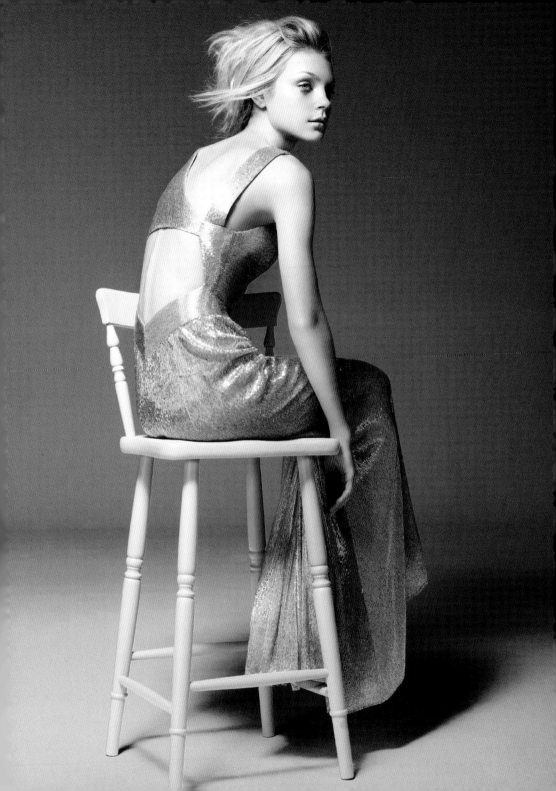

Everything comes back to film. 'It is a font of inspiration,' he says. 'If you read a book you create a sort of visual yourself but in film, the visual remains, it's very strong. There are many elements that come together to make that image, the work of the team, the photographer, the actor – yes – but also the food, the light, the sound, the clothes.'

In the sparse free time he allows himself, he likes to be at home, but even this simplest of pleasures is not immune from the famous Armani work ethic. 'Everywhere I go, I'd like to own a house, rather than living in a hotel, because a house is a haven for me. I have a pretty public life, and it keeps me very busy. When I come home I want it to be in my own home, with the right atmosphere, a place where I can relax and have a sense of serenity.' If home is where the heart is, then Armani's is certainly in Milan, in the Via Borgonuovo properties that serve as both his house and offices, but he also owns nine others – five in Italy alone – that he enjoys as holiday homes with his extended family (and whose furnishing led to the creation of the Casa range). Like his fashion, his interior designs adhere strictly to the Armani principles of lightness and discretion, and there's always a touch or reference to his favourite periods – Art Deco and the 1930s – in the atmosphere or in the shape of accents and furniture. 'I really love empty spaces, where I can always imagine adding things: I don't like the definitive setting, the finished thing, the handsome painting put in just the right spot which means nothing else could be added there. That is why my walls are empty, unadorned.' 'It sounds weird,' says his niece Silvana Armani talking to Lisa Armstrong in *Vogue*, 'the belief in what Armani stands for is so strong among

Freya Beha Erichsen wears a silk and chiffon asymmetric shoulder dress and satin shoes from the 2011 spring/summer collection almost entirely devoted to midnight blue. The theme – 'Night sky over the Sahara' – was reflected both in his palette and in fabric textures (sequins, devoré velvets, ribbon and beading) which evoked both a heady desert starscape and the twinkling night-lights of Manhattan. Photograph by Patrick Demarchelier.

'Easy elegance is at the core of Giorgio Armani's designs.'

VOGUE

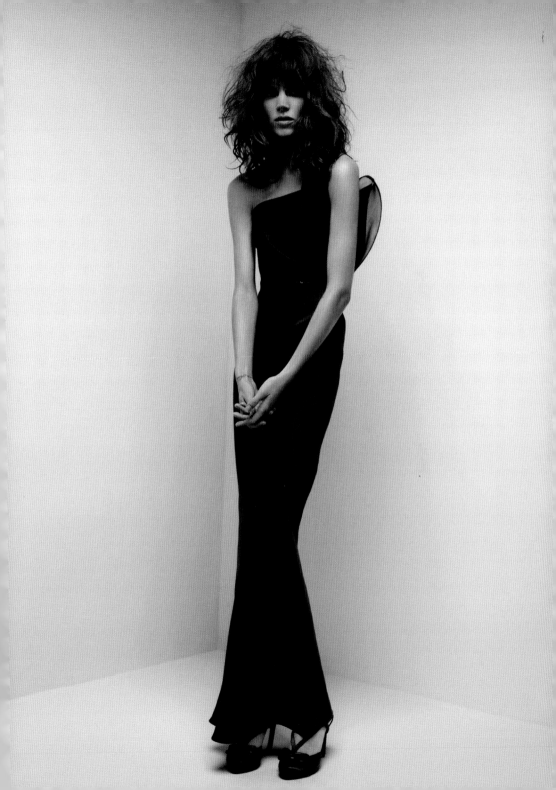

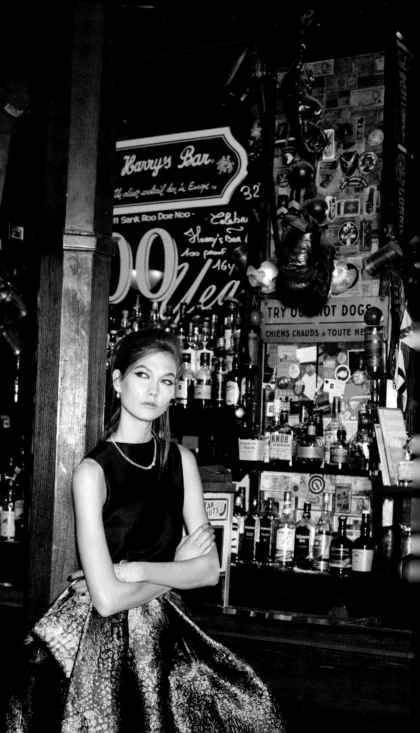

everyone here that you end up applying the principles to everything in your life.' When she redecorated her apartment she had some radical ideas, 'but I kept hearing his voice and surprise, surprise the place is mainly cream, beige and clutter free.'

Armani is at his happiest surrounded by a secure shell of his own making, and his ice-blue eyes light up at a mention of the 65-metre yacht which he designed every inch of, from port to starboard. 'Aah! This is my luxury.' Named Maìn after his mother's childhood nickname, the boat took 30 months to build and, since ultimately everything is work to Armani, many of the features once again ended up in Casa. Dark ('British racing') green and almost military in appearance, it was designed in response to the prevailing vulgarity of other vessels of this size. 'I saw too much white, too much lighting, too much marble, crystal and mahogany,' he says. 'The rich people who go on these traditional boats don't really care about the sea, for them it's like a hotel. I love the sea. I don't go and show off in those ports. I like to go further out.' Here, in his 'house on the water', he chooses the companionship of a dozen close friends to sail around the Italian islands, finally enjoying holidays by the sea that his family couldn't afford when he was young. 'In terms of the design for the boat,' he says, ' I wanted to limit the excess, so I attempted to free the decks of all the superstructures you normally see on them, such as tenders and other technical parts, which might break up the purity of line.' The result, naturally, is a floating template of subtlety and elegance, a sanctuary he spends at least a month of every year in, despite the fact that he is afraid of the water.

The *pièce de résistance* of his architectural endeavours, however, is the grand Teatro at Via Bergognone 59, designed with Tadao Ando, the self-taught Japanese architect with a kindred reverence for space and simplicity. Opened in 2002, Armani considers it his gift to Milan. From the outside, the former Nestlé chocolate factory in the Porta Genova suburbs fits its unglamorous setting two miles from his Borgonuovo base in the fashionable city centre. Step inside, however and you're transported to a space-age temple, with imposing giant

Simple and elegant: Karlie Kloss models a sleeveless black silk satin top and just-above-the-ankle-length ombré silk jacquard skirt, patterned in grey-green deepening to a blue-black hem. Photograph by Angelo Penetta.

walls and delicately lit rectangular pillars that run adjacent to a large shallow pool and minimalist garden. At the end resides the theatre itself, a space adaptable enough to hold exhibitions and operettas, but which primarily functions as the designer's very own bespoke catwalk. The blueprint was mapped out in just four face-to-face meetings. 'Armani's vocabulary is simple and classic,' said Ando. 'Every detail, from buttonholes to lapels, is considered.'

I t's often said that Armani is a safe designer, a backhanded compliment in an industry that thrives on taking risks. During a feud with his polar opposite, Gianni Versace, in the early nineties, the Calabrian compared his rival's style to that of an accountant. The criticism from fashion writers has long been that you can't tell Armani and Armani vintage apart, that his fashion shows are more like museum retrospectives. The man himself acknowledges that his dogged perseverance in pursuing his own vision has made him a few enemies along the way. And yet his expressive and sometimes surprising side is never more evident than in his love – and work – in music. When Lady Gaga was looking for eye-catching ensembles to dazzle at the 2010 Grammys, this avant-garde figure in popular music turned to the famously restrained Armani. While it might have been typical of Gaga to make an unexpected move, it was perhaps atypical of Armani to accept the challenge. The results, an iridescent dress with celestial swirling orbits and a high-cut glitter bodysuit with enormous shoulders, were such a success she hired him to design for her 2012 *Born This Way Ball* tour as well. Here the creations included a PVC bodice with spikes and Swarovski jet crystals, and a cubist composition of abstract guitars made from transparent Plexiglas, black crystals and luminous studs that even saw her sport a keyboard on her head. Perhaps all distinctly un-Armani, but then this is Armani having fun. 'Designing for Lady Gaga is always an exciting experience for me,' he told *Women's Wear Daily*. 'I admire the way she uses fashion as a scenic element and as a means to build a character. She is an artist of many talents and great intelligence.'

At the 2010 Grammy Awards Lady Gaga – and Armani – surprised the fashion world with a crystal-encrusted glittering hoop dress with orbiting rings like spun sugar.

Always enamoured and respectful of strong women, Gaga has not been his only client in the music business. There have been similarly cutting-edge outfits for Alicia Keys including a crocodile-print leather jacket with metal and sequins designed for her *Freedom* tour in 2010; a white silk organza skirt embellished by a pair of giant feathered wings for Katy Perry at the Grammy Awards in 2011; and collaborations and costumes for Tina Turner and Beyoncé. In another perhaps surprising departure, there was Barbie; the famous fashion doll sported a Giorgio Armani gown in 2003, inspired by a design on display at his Guggenheim retrospective in New York.

Saying 'yes' to Gaga seems to have been easier for him than agreeing to be the subject of that museum's first exhibition devoted to a single designer, as he was worried it might appear pretentious. This major event eventually opened in 2000, displaying 200 pieces in a special installation designed by architect Jean Nouvel, in collaboration with the theatre director and set designer Robert Wilson. The exhibition has since been a major attraction in Berlin, London, Milan, Rome and Shanghai. Visitors expecting a slew of mushroom-coloured jackets were amazed not only by stunning evening wear but also the nod in design to many non-Western cultures. The sarong, the kimono and the salwar kameez were all represented but always given the Armani touch and cut back to a sophisticated, wearable simplicity combined with some spectacular embroidery and beadwork.

Kate Moss photographed by Mario Testino looking casual in a silk-chiffon mermaid dress embroidered with silver and magnolia glass threads, from the Armani Privé 2008 autumn/winter collection. This gown with its spectacular embroidery and beadwork is typical of his ability to design something opulent that is also easy and wearable.

If his Barbie gown could be considered a triumphant meeting of high and low art, his wardrobes for the operas *Tosca* (at the 40th Festival della Canzone Italiana in 1997), *Cosi Fan Tutte* and *The Barber of Seville* in Milan (at Milan's Franco Parenti theatre in 1998) or his costumes for ballet and flamenco sensation Joaquín Cortés reflect his love of culture and offer examples of his enduring relevance in all walks of life. He has even designed for bullfighters and the Italian Olympic team. Though never a sportsman himself (unlike his brother Sergio) he is an avid watcher, with a soft spot for tennis, soccer and basketball.

服饰VOGUE
与
美容

十二月号
December 2014

造梦大师
TIM WALKER
镜头下的

笔墨幻境

睢晓雯
孙菲菲
双封面呈现
中国当代
书法家刘彦湖
挥毫题字

敦煌上演
大漠时装童话
杜鹃化身
轻盈花之精灵
佟大为童心四溢
忙而不盲

But with Armani, watching is never quite enough. In 2008 he bought local basketball team Olimpia Milano, now rechristened after his EA7 sportswear range (the name of the range itself contains the shirt number of former AC Milan football hero Andriy Shevchenko). In 2014 EA7 Olimpia Milano won their first championship for eighteen years and Armani himself lifted the trophy along with his captain and coach.

Within fashion, his relationship with football stands out. 'I believe footballers are today's new style leaders,' he said after dressing the Chelsea FC players in 2007, an enterprise that also saw him redesign their Director's Suite, renamed the Armani Lounge in his honour. 'Unlike others in the public arena, footballers are unique in the fact that they have to show an acute combination of mental and physical discipline which makes them genuinely heroic,' and in his advertising he has used his heroes most effectively. In 1996 England goalkeeper David James – looking every inch a Greek god – appeared in his spring/ summer 1996 Armani Jeans ads. Here again Armani scored: the first designer to select a soccer player as a style exemplar and one of the first to use athletic bodies as an endorsement for his clothes. When footballer Cristiano Ronaldo became the spokesperson for Emporio Armani in 2010, the designer opined, 'Cristiano is a great looking man with the perfect physique of an athlete. For me, he is the essence of youth.' 'I'm sure that if you asked any footballer, in any country, who their favourite designer was, the words "Giorgio Armani" would come tripping off their lips,' says Suzy Menkes. 'He's a name that's known across the globe, not just in the narrow world of the fashion community.'

Ronaldo was merely the latest in a string of high-profile sportsmen advertising the label, including Shevchenko, Brazilian footballer Kaka and tennis player Rafael Nadal. And if Richard Gere and Don Johnson were a coup for the brand in its early Hollywood years, then David Beckham was just as big a draw in the new millennium. *Vogue* had

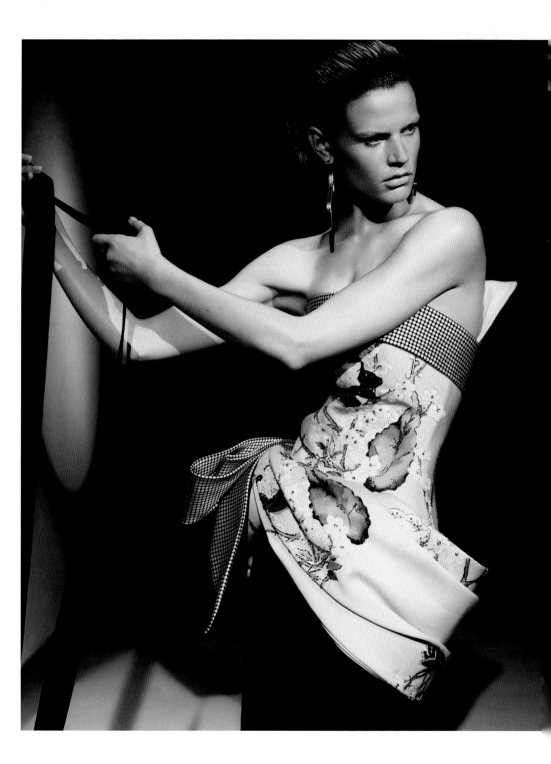

featured racing driver James Hunt, then the biggest style icon of the sporting world, in an Armani sports jacket as early as 1976. Three decades on, Beckham became a poster boy for Emporio Armani when he appeared in four underwear campaigns from 2008 to 2010. When he left, Armani's choice of replacement could hardly have been more apt. After Beckham had left Manchester United in 2003, the young upstart brought in to wear his number was an 18-year-old Cristiano Ronaldo. By the end of the decade Ronaldo had won the World Player of the Year Award that had always eluded Beckham, and recently moved to Real Madrid, the club Beckham had joined seven years earlier. That Armani should choose Ronaldo as the heir apparent hinted at a man with his finger still on the pulse of contemporary culture.

'Giorgio Armani deconstructs the kimono', says Vogue, 'to create a cherry-blossom-print corseted top that slips on over the new fluid velvet evening skirt.' Armani often references non-Western cultures including, for example, reworkings of the sarong and salwar kameez. Photograph by Mario Testino.

overleaf A line-up of new model faces for 2015 wear a selection of flawless tailoring. From pinstripes and trousers with braces to backless crêpe jackets and immaculate waistcoats, all are from the Armani archive, celebrating his fortieth year in business and revealing his enduring legacy. Photograph by Christian MacDonald.

However, Armani's steadfast resistance to trends in favour of timeless chic can bolster the perception that he's not interested in the fashion world outside his own walls, within which he has complete control. A certain conservatism certainly applies to his own sartorial choices: an unchanging wardrobe of navy t-shirts, sweaters and matching well-cut trousers. 'The man who revolutionized men's fashion invariably appears in a crew neck navy sweater, simple slacks and elegant English shoes,' writes John Fairchild in *Chic Savages*, and not much has changed since then. It's as if, having constructed himself a uniform for every day, he can then focus on more important things; for him, designing 'requires a deep understanding of one's self and a form of internal severity. It means going beyond the concept of trends in order to express one's own taste.' He is undoubtedly autocratic. What he says goes. 'You can disagree with him, but there's not much point. He's always proved right in the end.' Leo Dell'Orco told British *Vogue* in 1994. To his staff he's not so much unapproachable as irreproachable. It's always 'Mister Armani', never Giorgio. 'I don't see him as a despot, more like a father,' says Dell'Orco, who has worked with him since 1974.

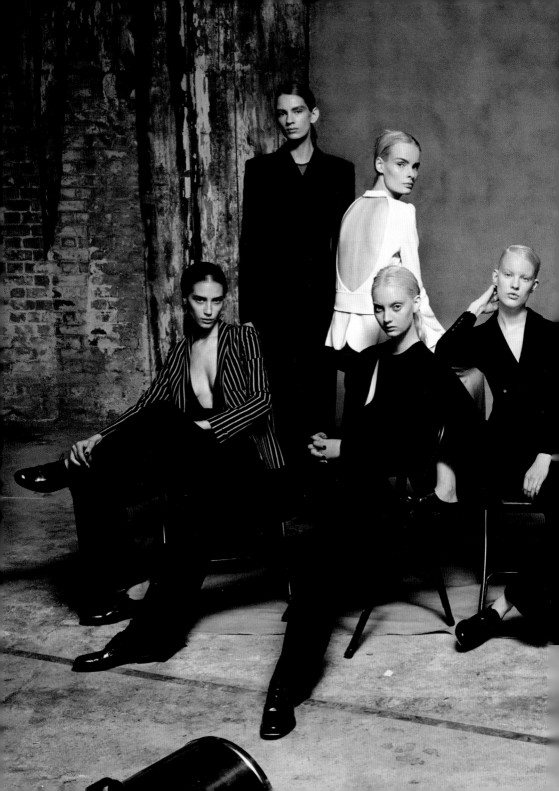

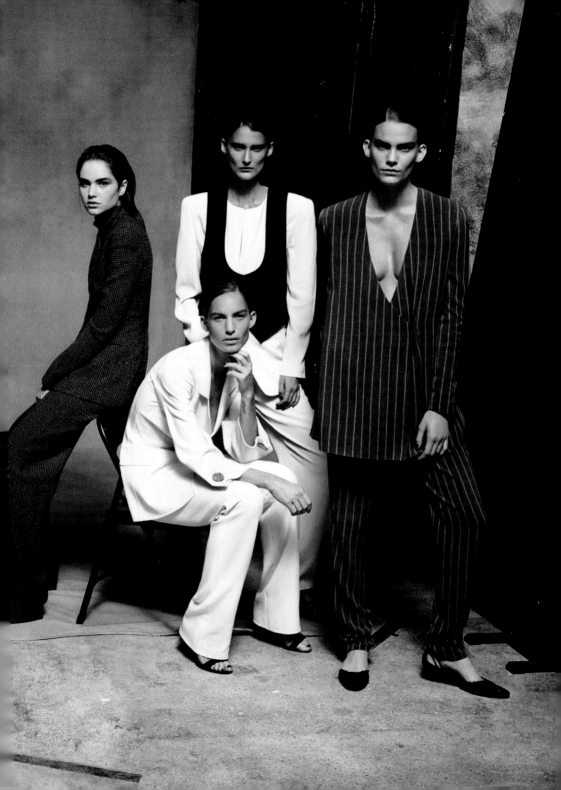

'Maybe not the father you would choose … I'm joking. He's tough. But at least you know instantly when something you've done isn't right.'

This paternal attitude has been felt by a collection of up-and-coming talents. As far back as 1985 he was poised, thanks to the vision of Sergio Galeotti, to invest in Vivienne Westwood at a time when, despite her kudos in the fashion world, she had very little money, though the deal fell through because of Galeotti's untimely death. In recent years a group of hand-picked young designers have been invited to show in his hallowed and regal Teatro as a way of helping them to promote their designs. For the spring 2015 menswear season, he hosted Christian Pellizzari on his famous catwalk, and for the women's shows in September, Angelos Bratis, a young Greek designer who shares his clean and minimalist aesthetic. 'For me, the great Italian maestro is the perfect example of a designer who has deep values, expressed throughout a long career,' said Bratis. 'These are the same values that I try to express in my work: femininity and pure elegance without artifice.' It's not just kindred spirits either. Stella Jean, a 34-year-old Italian-Haitian who creates vivid, colourful clothing, mixing prints with African handwork and Italian craftsmanship, was also given, in her own words, 'a Giant's helping hand'. 'The pallid walls and minimalist architecture of the Tadao-Ando-designed Armani building can never before have been filled with such vivid colours and patterns,' noted Suzy Menkes in the *New York Times*. For Armani, the project is almost as fulfilling for him as his grateful protégées. 'My initiative in supporting little-known but promising designers is paying off, and personally I'm quite passionate about it. The future of the system depends on new generations, and I am happy to be able to contribute in an active way.'

Perhaps, at 80, Armani is starting, albeit reluctantly, to look to his legacy – to the next generation that will continue his good work.

A bustier-style velvet evening dress covered in a starry sky of crystal embroidery. Mario Testino's photograph of Chinese supermodel Fei Fei Sun has – appropriately for Armani – a filmic quality and almost a scent of the 1920s.

overleaf *A black velvet and silk-chiffon jacket comprised of ruffles, worn over loose velvet trousers (left); these are from a 2008 winter collection in which concertina pleats, ruching and ruffles in satin, teamed with loose velvet skirts and trousers, gave a nod to the Edwardian period. A different era is referenced here (right); this sharp forties silhouette in a floral print dress shows that Armani likes to surprise. Photographs by Emma Summerton.*

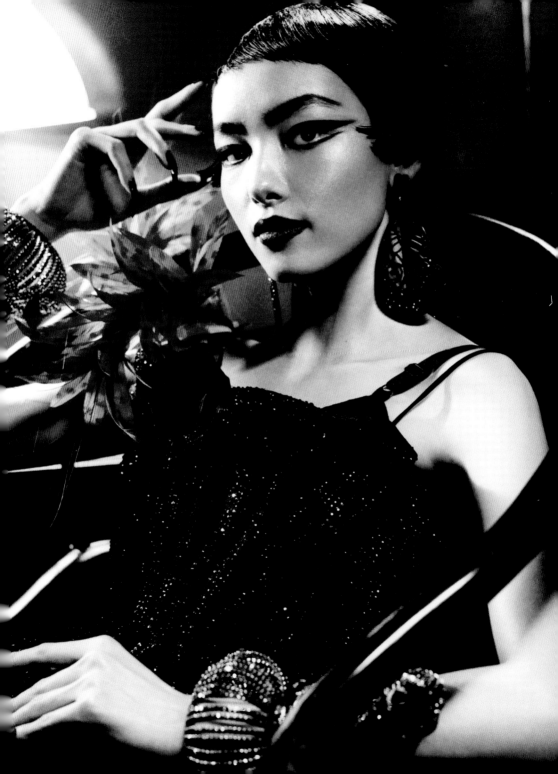

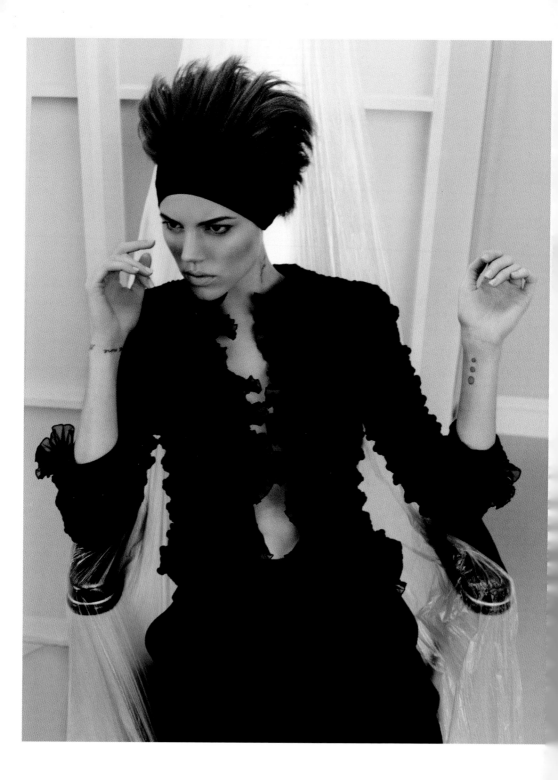

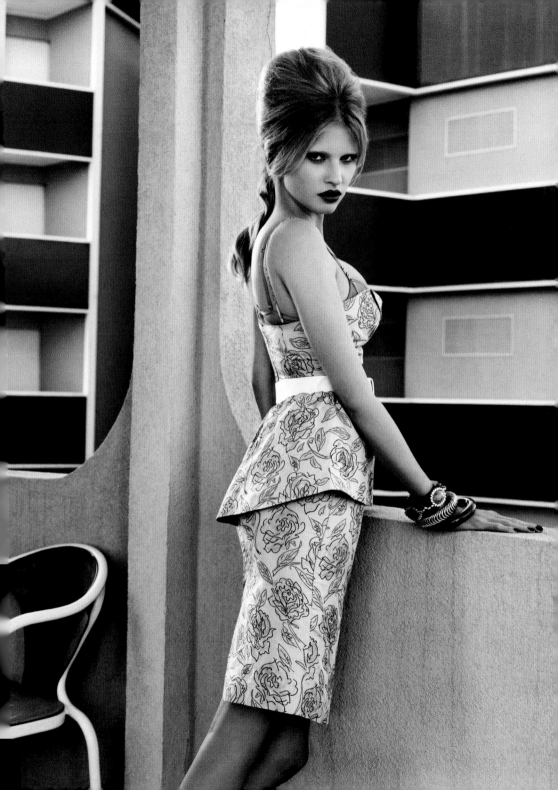

He has confirmed the opening, in Via Bergognone, of a new exhibition dedicated to fashion, design and art, and which will contain collections of clothing, drawing, images and experiences gathered during his long career. 'Armani Silos', built from the remaining Nestlé silos near to his Teatro, will not just house a museum archive of the designer's own work, but also act as a cultural centre, open to the arts and to those who study fashion. It will include a library, spaces for research students and for conferences and events. 'Sort of my own Tate Modern,' he says.

The question of who will succeed the designer has been the subject of industry interest for decades and it has been suggested that he might create a foundation to protect the future of his empire similar to the Hans Wildorf foundation behind the watch brand Rolex. As a designer or businessmen, there is certainly nothing left for him to prove. There are few honours that don't already bear his name, from his *Abrogino D'oro* in 1982, to his *Légion d'honneur* in 2007; he won his first lifetime achievement award in 1987, a mere twelve years after his formal debut, and his retrospective exhibition that began at the Guggenheim in New York has since been a major attraction in Berlin, London, Milan, Rome and Shanghai. Only a very small group of designers have achieved such cultural immortality or are as globally revered, and not one has such singular control over their empire as Giorgio Armani. None of this would have been possible however, if he hadn't revolutionised the fashion industry with, of all things, simplicity.

Armani's principles of lightness and discretion and touches of his favourite periods – Art Deco and the 1930s – are reflected in a grey-blue organza iridescent halterneck erupting in a waterfall of pleats that could have been imagined for Daisy Buchanan in Scott Fitzgerald's The Great Gatsby. Photograph by Willy Vanderperre.

overleaf *The cardigan jacket, one of the very first classic garments that Armani took apart and reworked, is worn here as part of a trouser suit (left) in 2014, though its elegant silhouette is almost impossible to date, perfectly illustrating his timeless appeal. Photograph by Karim Sadli. Cinematic moods permeate Armani's packaging, his designs and his advertising. They are seen (right) in Boo George's shoot for the autumn 2014 Emporio Armani campaign on a deserted sandy beach with girls in archetypal Armani and oversize bowlers.*

'Armani will forever be known as the man who took his scissors to the structure of our clothes and yanked the claustrophobic skeleton out of them.'

VOGUE

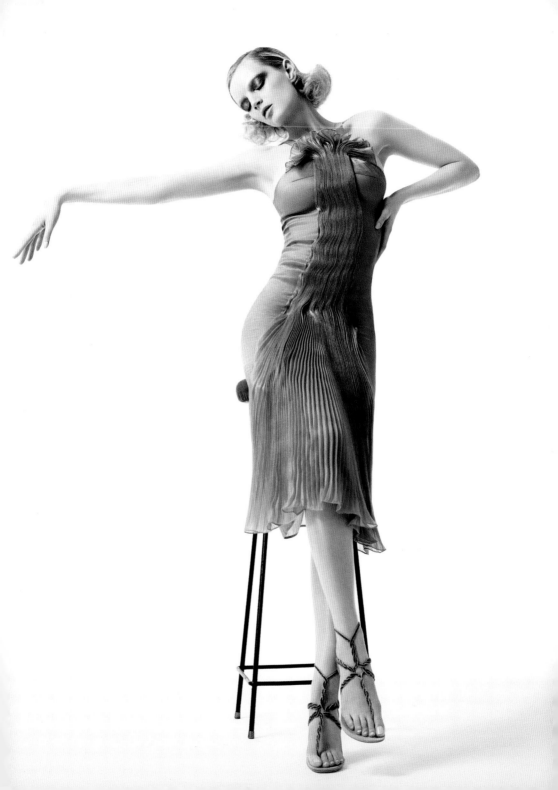

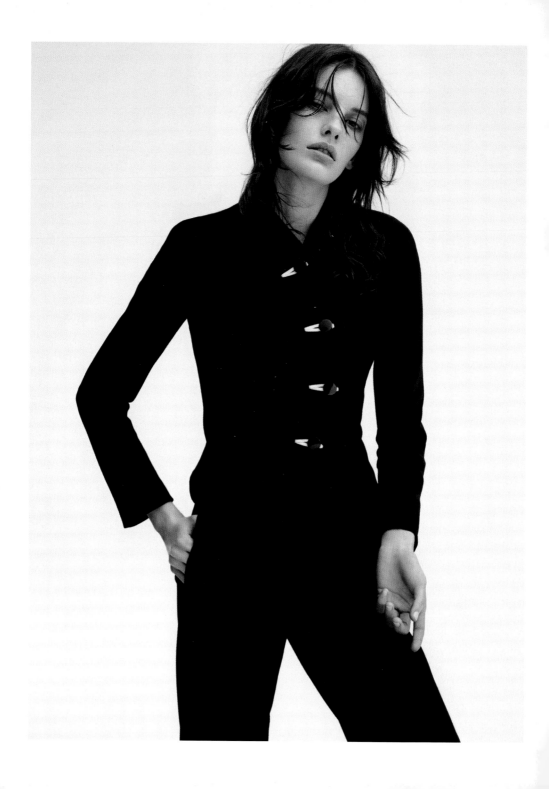

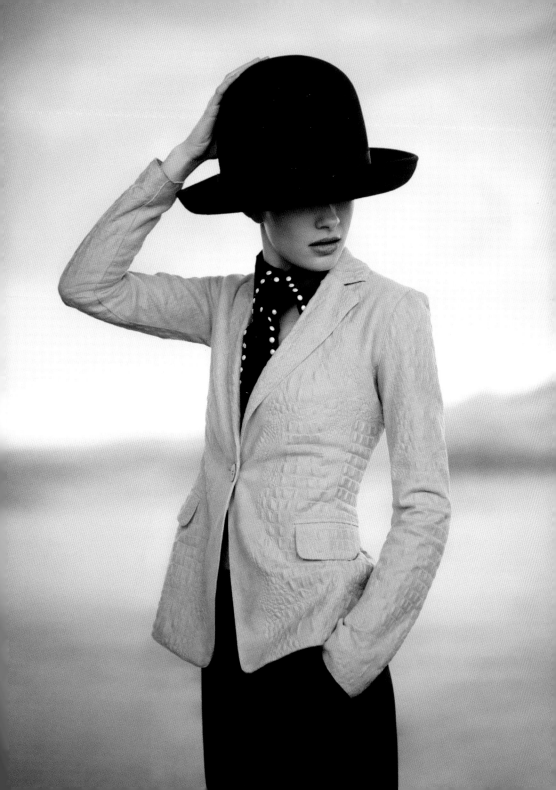

Index

Page numbers in *italic* refer to illustrations

References

Giorgio Armani: Images of Man by Richard Martin and Harold Koda. Rizzoli New York, 1990

Giorgio Armani by Germaine Celant and Harold Koda with Susan Cross and Karole Vail. Guggenheim Museum, 2000

Being Armani: A Biography by Renata Molho. Baldini Castoldi Dalai, 2007

In Vogue by Georgina Howell. Penguin Books, 1978

In Vogue: 75 Years of Style by Georgina Howell. Condé Nast/Random House, 1991

Chic Savages by John Fairchild. Simon and Schuster, 1989

McDowell's Directory of Twentieth Century Fashion by Colin McDowell. Frederick Muller, 1984

Fashion Source Book by Amy De La Haye. Macdonald Orbis, 1988

Perfumes: The Guide by Luca Turin and Tania Sanchez. Profile Books, 2008

The Book of Perfumes by John Oakes. Prion Books, 1996

Made in Milan by Martin Scorsese (documentary on Armani), 1990

Picture References

All photographs © The Condé Nast Publications Ltd except the following:

Author's acknowledgements:

I would especially like to thank Oscar Pye-Jeary for his enormous work on the research and writing of this book. Thanks also, to Ben Evans for his tireless help and enthusiasm for picture research, sourcing and permissions as well as to Brett Croft, Library and Archive Manager at Condé Nast. Thanks to Harriet Wilson, Director of Editorial Administration and Rights, for her help and guidance as well as to Sarah Mitchell, my editor at Quadrille. Great *Vogue* friends like Lisa Armstrong and Suzy Menkes gave me valuable insights, as did make-up supremo Linda Cantello. Photographers Boo George and Benjamin Lennox kindly gave me pictures and I couldn't have written this book without *Vogue*'s archive material and illuminating reports from brilliant journalists such as Sarah Mower, Alexandra Shulman, Tim Blanks, Dodie Kazanjian, Sarah Harris and Nicola Moulton to name just a few – thank you all. In Milan, Anoushka Borghesi, Global Head of Media & PR Giorgio Armani S.p.A, was endlessly helpful as were Stefano Peradotto in the Press Office of Giorgio Armani S.p.A, Sabrina Taveggia and Michi Prendin. Finally I am very grateful to Mr Armani himself who found the time in his hectic schedules to talk to me and personally answer all of my questions.

Publishing Consultant Jane O'Shea
Creative Director Helen Lewis
Series Editor Sarah Mitchell
Series Designer Nicola Ellis
Designer Gemma Hayden
Production Director Vincent Smith
Production Controller Emily Noto

For *Vogue*:
Commissioning Editor Harriet Wilson
Picture Researcher Ben Evans

First published in 2015 by Quadrille, an imprint of Hardie Grant Publishing

Quadrille
52-54 Southwark Street
London SE1 1UN
quadrille.com

Text copyright © 2015 Condé Nast Publications Limited
Vogue Regd TM is owned by the Condé Nast Publications Ltd and is used under licence from it. All rights reserved.

Design and Layout © 2015 Quadrille Publishing Limited

Cataloguing in Publication Data: a catalogue record for this book is available from the British Library.

ISBN 978 1 84949 468 7

Reprinted in 2018
10 9 8 7 6 5 4 3 2

Printed in China